SCATTER MY ASHES AT BERGDORF GOODMAN

SCATTER MY ASHES AT BERGDORF GOODMAN

Sara James Mnookin

Foreword by
Holly Brubach

HARPER
DESIGN

An Imprint of HarperCollinsPublishers

CONTENTS

FOREWORD

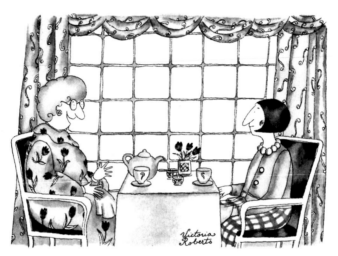

"I want my ashes scattered over Bergdorf's."

From an early age, I loved stores and the theater of shopping. I even had fantasies of being locked in a department store after closing, having the place to myself and roaming the floors, spending the night. I would dine in Housewares and sleep in Linens, in pajamas selected from the racks in Lingerie. Unquestionably, there were things I coveted, but my fascination with stores and shopping was not motivated by the urge to acquire so much as by the pleasure of discovery.

Media in those days—in the Dark Ages, before the dawn of the Internet—consisted of newspapers, magazines, and television, but looking back, I see that stores were media too: from the *grands magasins* of Paris, commemorated in luscious detail in Émile Zola's *Au bonheur des dames*, to the Main Street importers of dry goods in small towns strung like beads along the railway lines that crossed the map of America. A store was an emporium, a place where people came not only to buy but also to browse, a de facto museum filled with beautiful and useful artifacts, displayed in their own time, available for sale. Before everyone had been everywhere and seen it all, stores brought their customers the world.

Opposite:
Victoria Roberts's
infamous
cartoon first
appeared in
The New Yorker
in 1990.

After college I moved to New York City and took a part-time job, working afternoons at a fashion magazine, and Bergdorf Goodman was along the route I walked to my office. Some days I lingered in front of the windows; others, I cut through the first floor, entering in Cosmetics and exiting through Van Cleef & Arpels. The merchandise was an object lesson in connoisseurship. The detour added no more than five or ten minutes to my walk, and I came to regard it as a quick adventure, a brief escape from the routine of my still unformed, sparsely furnished life.

The oasis of calm, with the bustle of Fifth Avenue beyond the doors. The impeccably polite demeanor of the staff. The quiet presence of the proprietor's family living upstairs, over the store, in a penthouse apartment under the mansard roof. The silver box and lilac bag in which some newfound treasure made the trip home. If Paris was for me the acme of civilization, Bergdorf—its architecture reminiscent of a Gilded Age mansion, its plush salons, its sublime refinement—had grafted Paris onto New York.

That proprietary blend of Avenue Montaigne chic and Park Avenue style would qualify today as a case study in corporate branding, but when I made

the store's acquaintance back in the late seventies, nobody but a few farsighted business-school professors thought in those terms. Still, stores, like people, had personalities. Bonwit Teller was your dowager aunt, dignified and straight-backed, dropping the name of a rock band or the latest film just to let you know that she kept up. Bloomingdale's, brash and kinetic, was a working girl who partied hard. Henri Bendel was an urban original, witty and artistic. And Bergdorf Goodman was a woman at home in the world, glamorous, discreet, with an elegance that informed her every gesture.

I liked them all, but it was in Bergdorf's company that I wanted to pass the coming years. I became a customer, and Bergdorf took me on, treating me with all the deference and kindness of a friend. I bought my clothes there, and for eleven years they were fitted by Elvira Nasta, a gifted seamstress who worked in the alterations department.

Elvira had the sartorial equivalent of a piano tuner's perfect pitch and a vast repertoire of tricks to make a garment—any garment—look as if it had been designed and made for me expressly. She saw me on my fat days and on my thin days. She knew

the ways in which my figure deviated from the standard sizes, and she passed no judgments. We talked a lot, mostly about food, men, and getting older, and we laughed often. We spent countless hours together in a fitting room the size of a boudoir: me, concentrating on standing tall, balanced on the high heels I would wear with the dress in question; Elvira with her pincushion, moving in slow circles around me, calibrating the hem, scrutinizing the contour of every seam.

When after twenty-six years she retired, I was bereft, although I knew better than to think that Elvira would miss me as much as I would miss her. As a kind of farewell exercise, I interviewed her for a column I wrote in the *New York Times Magazine*. She told me she was enjoying retirement, but the satisfaction her work had brought her was gone. "When a garment was all finished and I'd see the woman dressed, it gave me great pride," she said. Leaving the house for a meeting, a dinner, a fancy-dress ball, I had the feeling that Elvira's good wishes went with me, sewn into the outfit I was wearing, like a fairy godmother's benediction.

In these days of search engines, one-click orders, and free shipping, it's difficult to talk about how much Bergdorf Goodman has meant in the lives of its customers—in the life of this customer in particular—without sounding hyperbolic and sentimental. As I write, a voice in the back of my mind keeps advising me to discount these recollections. This is, after all, shopping we're talking about. Listen, I tell myself, it was just a store.

But it wasn't. And it isn't.

—**Holly Brubach**

INTRODUCTION

Edwin Goodman could never have fathomed what lay ahead when he left Lockport, New York, borrowed some money from his uncles, and purchased a stake in Herman Bergdorf's Manhattan atelier. The year was 1901, and Bergdorf, a gregarious Alsatian immigrant and gifted tailor who lacked ambition, spent much of his time at Brubacker's wine saloon, leaving his clients to wait.

Goodman, at just twenty-five, was handsome and serious, with a drive and dedication beyond his years. He seemed, at first, to be the ideal partner for Bergdorf. The ladies' suit had just come into fashion, and from its modest perch at Fifth Avenue and Nineteenth Street, the newly formed Bergdorf Goodman was turning out some of the city's finest. As orders rolled in, Goodman urged his elder partner to move the operation uptown, to a bustling stretch of Fifth Avenue known as Ladies' Mile.

Shortly thereafter, while Goodman was honeymooning in Europe, Bergdorf did move the store—but not to the swanky address his young partner had been envisioning. Instead of opening directly on Fifth, next to prestigious dry goods emporiums

and department stores such as B. Altman, Lord & Taylor, and Best & Co., Bergdorf leased a sleepy spot at 32 West Thirty-Second Street. A man whose lone indulgence was a bottle—or three—of Alsatian wine didn't see the point of spending on Fifth Avenue frontage.

The out-of-the-way location irked Goodman from the moment he returned to New York. He bought out his partner, and Bergdorf headed off promptly thereafter to Paris to retire happily a free man.

In 1914, Goodman upgraded to a five-story building at 616 Fifth Avenue, constructed to his specifications. Though he initially sublet some of the square footage to help cover his costs, he still had far more space than the cramped quarters on Thirty-Second Street. However, once he hired Ethel Frankau, a stylish schoolteacher-turned-dressmaker, his client list quickly grew to fill up every floor.

Goodman had never been satisfied to follow trends in women's couture. He toyed with convention, adding box pleats to hobble skirts, encouraging clients to discard the Victorian jabots around their necks and constricting corsets about their waists, cutting furs to the body so they were no longer

bulky and unflattering, and, most important, introducing quality ready-to-wear in the twenties.

Frankau was every bit his equal. She emphasized the bias cut before others caught on to its importance and devised a new bateau collar—or boatneck—for the flapper silhouette. As the store's couture buyer in Paris, she displayed a nearly flawless eye for what would sell in New York, choosing just the right looks to import and duplicate for her customers in the Bergdorf Goodman sewing rooms.

Under Goodman's tutelage, the former schoolmarm became a legendary fashion director, consulted for her trusted advice and opinion by style icons no less than Jacqueline Kennedy. Together, Goodman and Frankau were unstoppable. There seemed to be no limit to Bergdorf Goodman's success.

But then Goodman learned of a significant threat to 616 Fifth Avenue. A major development project—Rockefeller Center—was in the works that would necessitate leveling several blocks of prime Midtown real estate, including his own.

Once again, he would have to move the store.

A few blocks north, Cornelius Vanderbilt II's widow, Alice Claypoole Gwynne Vanderbilt, had

begun a long and agonizing debate over what to do with 1 West Fifty-Seventh Street, the 130-room turreted mansion her husband had left to her in 1899. The house, built by architects George B. Post and Richard Morris Hunt and modeled on the stately chateaus of France, was the largest private residence ever to be constructed within an American city. Louis Comfort Tiffany had designed its opulent Moorish tiled smoking room, with inlaid mother-of-pearl walls. A Louis XVI music room had been imported straight from Paris. And the entrance facing Central Park featured a tower and grand porte cochere.

But sprawling as it was, Alice's home was being engulfed by neighboring commercial towers. The 250-foot rebuilt Plaza Hotel had opened October 1, 1907, joining the nearby Savoy Plaza and New Netherland. Alice was also no longer grieving just for her husband. She lost three of her sons before the first quarter of the twentieth century was out, leaving her home at 1 West Fifty-Seventh Street feeling increasingly like a cavernous empty nest.

In 1925, just as the Savoy Plaza, Sherry-Netherland, and Pierre hotels were rising up the street, Alice

Opposite:
The Cornelius
Vanderbilt
residence,
Fifth Avenue
and Fifty-Eighth
Street.

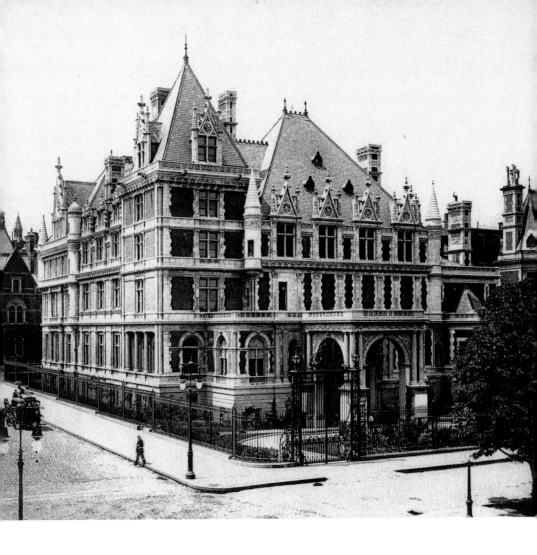

sold the mansion to the Braisted Realty Corpora-
tion for $7.1 million. The following year, in one of
the great travesties of Manhattan real estate, the
former home of Cornelius Vanderbilt II was razed.

Before the wrecking crews set to work, Alice
arranged to let the public tour the mansion for a
fifty-cent admission, with the proceeds going to the
New York Association for Improving the Condition
of the Poor. Today, very little remains. An Augustus
Saint-Gaudens mantle is with the Metropolitan
Museum of Art. A bas-relief from the porte cochere
now sits at the entrance to the Sherry-Netherland.
Movie tycoon Marcus Loew salvaged a Tiffany
Moorish smoking room from another Vanderbilt
mansion (at 660 Fifth Avenue) and moved it to the
Midland Theatre in Kansas City, but its equivalent
at 1 West Fifty-Seventh Street was too ornate to dis-
assemble and relocate. (Loew did, however, snag its
fanciful chandelier for the foyer at the Loew's State
Theater in Syracuse, New York.) Thanks to Alice's
daughter, Gertrude Whitney, a pair of the mansion's
carriage gates was preserved and installed at the
Conservatory Gardens in Central Park, at 105th Street
and Fifth Avenue.

Nearly everything else was pulverized and carted to a landfill in New Jersey.

In the Vanderbilt location, Goodman saw a golden opportunity. Here, finally, was the site for his dream atelier. With sweeping views of Central Park, and just steps from the moneyed travelers now frequenting the surrounding luxury hotels, this would be a dressmaking business unrivaled in New York City—a true Parisian house of couture. Its entrance would adjoin the proud carriage walk encircling Grand Army Plaza and the cascading Pulitzer Fountain, bequeathed by publishing tycoon Joseph Pulitzer in 1911. And after leapfrogging up Fifth, four times in less than three decades, Goodman would now be at the leading edge of the Midtown shopping district. No other store could venture farther north without landing in the pond at Central Park.

Working with the architectural firm Buchman & Kahn, Goodman helped design an elegantly understated nine-story Beaux-Arts beauty to occupy the full block of Fifth Avenue between Fifty-Seventh and Fifty-Eighth Streets. According to legend, he himself sketched out the restrained mansard-roofed edifice on a cocktail napkin in the bar at the Plaza. The building was constructed

to function as a series of townhouses, carved up and let to various vendors. Bergdorf Goodman would be the anchor tenant, occupying the prime corner at Fifth and Fifty-Eighth, at an annual rent of more than six figures.

On the day Goodman signed the papers, he was visibly calm, but inside, he was a wreck. He now had a wife and two school-age children to support. He wasn't sure he could afford payments on even a fraction of the space. For the first time in his life, he felt as if his reach might have exceeded his grasp.

Once again, Goodman gambled, and once again, it paid off. The new store opened in 1928 to an almost instant profit, and soon Goodman was able to buy outright the portion of the building he had recently feared he wouldn't be able to lease.

Just a year after Bergdorf Goodman on the Plaza opened, Black Tuesday hit, bringing with it the horrific stock market crash of 1929. By all reasoning, Goodman should have been wiped out. Instead, his business thrived. Women still needed dresses, and Bergdorf Goodman was now just steps from Manhattan's burgeoning Upper East Side. Rather than venture downtown, past vacant storefronts and endless breadlines, members of Manhattan's surviving

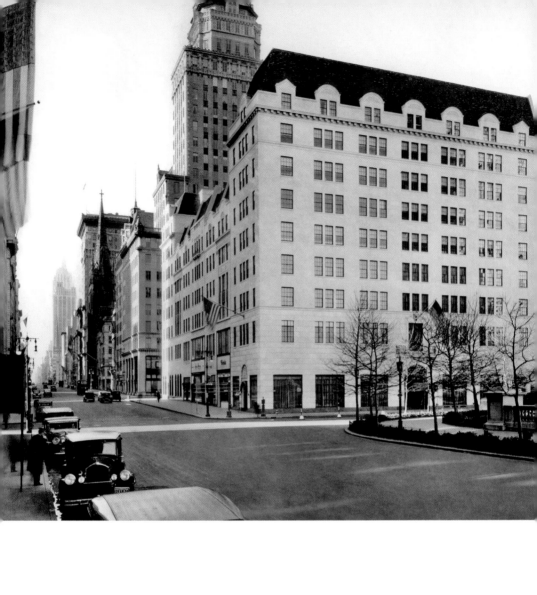

classes escaped to Bergdorf Goodman, where they could still feel safe, as if the world wasn't collapsing around them.

Goodman did so well during the Depression that the building's other mortgage holders came to him with generous offers, and by the time Germany invaded Poland, launching World War II, Goodman owned the entire block.

Only the finest materials had been used during the building's construction. In lieu of limestone, Goodman insisted on importing white marble for the facade, at an additional cost of $60,000. "The architects really understood this was not just a place to shop," Paul Goldberger, Pulitzer Prize–winning architecture critic for *The New Yorker*, says. "It was on an important corner and would affect the spirit of the city. The Vanderbilt mansion was a great building, but it was replaced by another truly good building. Bergdorf Goodman is dignified. It connects to everything around it and enriches Grand Army Plaza. It was never as grandiose as some of the other department stores, like B. Altman or Hugh O'Neill on Ladies' Mile. There's something almost domestic about it, and I think that was very deliberate."

Indeed, Goodman designed the Renaissance Revival interiors—with soaring ceilings and intricate plasterwork—so that his privileged clients would feel they were in an extension of their own homes. They did. So did he. He moved his family into the penthouse above the store.

The Goodman apartment was unlike any other in New York City. Occupied continuously by members of that family for sixty-five years, it was frequented by a parade of luminaries, including Benny Goodman, the Duke and Duchess of Windsor, and Barbra Streisand. Edwin and his wife, Belle, raised their daughter, Ann, and son, Andrew, there. Then Andrew and his wife moved in with their four kids.

Entering from the street, visitors passed through a set of huge brass doors "that would close like a tomb behind you," according to one frequent guest. Inside, a long Art Deco hall led to an elevator containing fresh floral arrangements and the ultimate luxury: a telephone line, wired upstairs, to the store and to the outside world.

A second lift reached the apartment through the main Bergdorf Goodman elevator banks. "There were a few customers who got on the wrong elevator

and occasionally ended up in the family's dressing rooms," says Susie Butterfield, a former senior vice president. "But the Goodmans were always very charming and relaxed about it."

Because much of the store's inventory was sewn on-site, the building was classified as a factory and had to adhere to strict fire codes. The bones of the apartment were therefore flameproof. Windows were steel casement. Floors were terrazzo, marble, tile, or carpet over concrete. The drawing room only looked like it was paneled in rich walnut—its surfaces were actually plaster, painted trompe l'oeil to look like wood.

In the early years, in order to live there legally, Edwin and Belle were designated as janitors—though it's doubtful either of them ever wielded a mop or broom.

"What I remember most is just the space," Joshua Taylor, Edwin Goodman's great-grandson, says. Most New Yorkers live in tiny, cramped apartments, but this was a rambling seventeen-room abode, with a proper dining room, a living room, enormous bedrooms—each with their own changing rooms and bathrooms—and spacious service areas, including a huge kitchen with a butler's pantry and a dumbwaiter.

"When I was sixteen and working at the store as a stock boy for the summer, the other guys would sneak off someplace to have their sandwiches," Taylor says. "But I would head upstairs for lunch. Of course, I didn't tell anyone where I was going—I didn't want to be treated differently. There was always something clandestine and fun about going up there."

Edwin's son, Andrew, had a striking presence, much like his father. Groomed almost from birth to take over Bergdorf Goodman, he was a spirited bon vivant. After his sophomore year at the University of Michigan, Andrew was sent by his parents to work with the designer Jean Patou in Paris. But the Bergdorf Goodman heir apparent spent most of his time in the City of Lights assisting the French police in a sting operation to break up a forgery ring, zipping around in his red Delange sports car, and wooing young French lasses with Bergdorf's discarded couture samples. "Really, you could faint sometimes," Susie Butterfield says. "Andrew Goodman was such a divine man and charmed everyone."

It was a vivacious Cuban divorcée who finally charmed him right back, on a yacht in Havana.

Living above the shop *in New York City*

The Andrew Goodmans do it the luxe way, in an apartment atop Bergdorf Goodman, where they can see, in lieu of a front lawn, the green sweep of Central Park. Responsive to the lure of the city, they now usually split the week between their Westchester house and the Fifth Avenue *pied à ciel* shown, in part, here, as recently redesigned by Jan Moran, of Bergdorf's decorating department. The shop, above, seen from across New York's famed Plaza; the Plaza, right, seen from a penthouse window, looking out over a skirted table dedicated to fresh flowers, small pictures, and Mrs. Goodman's collection of antique snuff boxes and patch boxes. Collector's prize, in the drawing room, below: the Queen Anne secretary-bookcase, a rarity.

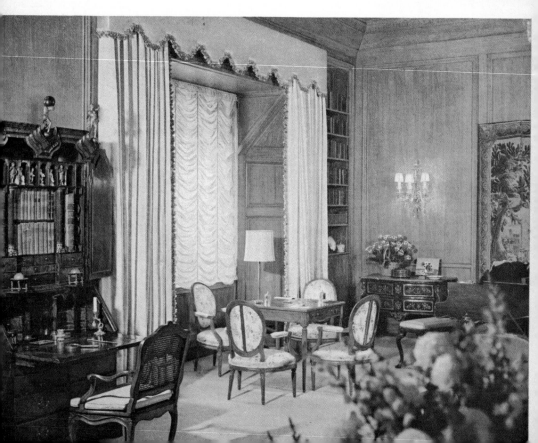

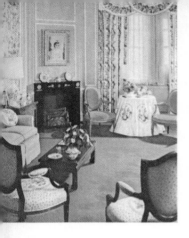

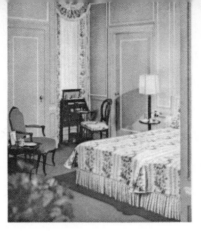

The sitting-room and sleeping areas, left, that make up the master bed-room, its well-molded walls papered with lightly patterned silk. Combined bath and dressing room, below, with a silky-soft fluff of Icelandic goat's hair as a luxurious white rug.

Another view of the drawing room, below, where a once-dark fireplace has gone cheerfully and beautifully blond, where the replacement silks, brocades, velvets sound a gentle chime of lighter, livelier tones, where all the changes contrive to enhance the hospitable air of the wide, high-ceilinged room. Hospitable indeed—it's a great place for parties.

PHOTOGRAPHS BY HOWARD GRAFF

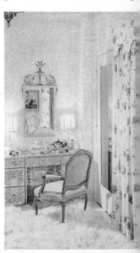

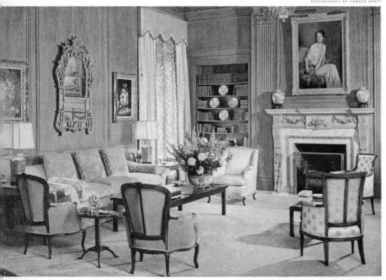

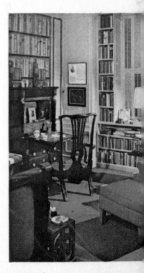

Two glances, right, at Mr. Goodman's study, once his boyhood bedroom. Set on a low dais, an Empire sleigh bed and a narrow Chinese lacquer table. On the wall behind the leather chair, built-in cases full of books—real ones, these, competing, in decorative value, with the trompe l'oeil library that lights another wall with colors.

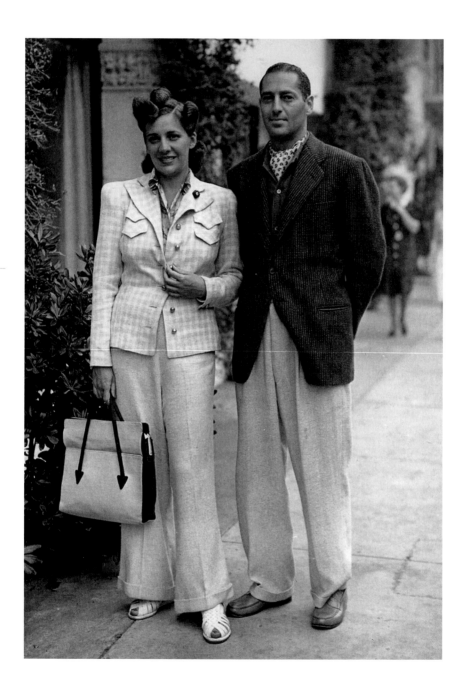

Andrew persuaded Nena Manach to move to New York, and despite his father's early reservations, they married—though only after Nena signed a prenuptial agreement. A lively, carefree couple, they drew designers and other notables into their inner sanctum.

"I have the memory of a mosquito, but I do remember going up to the Goodmans' apartment for dinners," designer Oscar de la Renta says. "Nena and I got along very well—she was Cuban and we spoke Spanish to one another. Andrew Goodman was a friend. I don't really know how they managed to separate private life from public life, but I think it gave to Bergdorf Goodman an identity that no other store has. There is a feeling when you walk in that you are being welcomed into a home."

Sometimes, the effect could be jarring, like when Andrew would venture downstairs in his smoking jacket to check up on employees who were working late, or when Nena sashayed through the store to shop.

"I was doing a trunk show at Bergdorf in the eighties," designer Michael Kors says. "I was probably twenty-two or twenty-three, with shoulder-length blond hair—full Peter Frampton insanity. And I

Pages 30 and 31: The Andrew Goodman family penthouse above Bergdorf Goodman, photographed for *House Beautiful*, 1965. Opposite: Nena and Andrew Goodman, Palm Beach, Florida, 1939.

looked out of the corner of my eye and I saw this very glamorous woman come walking through the third floor in marabou slippers and a chiffon peignoir, with a kimono over it. She was smoking a cigarette, trailing ash, and she wanted to know if I made any caftans. And I thought, 'How fabulous is this woman shopping dressed like this?' It was Nena Goodman. She was still living upstairs."

Nena stayed in the apartment until Andrew passed away in 1993. When she moved permanently to their home in Westchester, the store absorbed the penthouse. Its interiors were kept intact for a brief period, as Bergdorf Goodman fashion shows and events once again filled those grand rooms. But in the end, the apartment was dismantled. The space became the John Barrett Salon.

"I was lucky enough to see the apartment before they tore it down," James Lopilato, a longtime Bergdorf Goodman doorman, says. "I got close to the guys doing the demolition, and when they were throwing stuff out, they let me keep some things—wall sconces, pendant lights. My mother's address is two, so I got the metal number from the old entrance, for 2 West Fifty-Eighth Street."

The removal of the Goodman apartment wasn't the only significant change the building has seen since it first opened in 1928. There have been major and minor renovations at 754 Fifth Avenue at many points over the years, including weaving new wiring, central air-conditioning, and sprinklers up through the historic space. Escalators were added in 1983. More recently, senior vice president of the fashion office and store presentation, Linda Fargo, oversaw a reorganization of the main floor. "It took me about seven years of lobbying our principals of the company," Fargo says. "But I feel it was an inventive renovation."

"I love that Bergdorf is always changing," designer Alber Elbaz says. "It's a very organic place. Every time you come, it's something else."

One of the more remarkable additions happened in 1969. In the midst of a storewide update, Andrew Goodman was searching all over the world for just the right chandelier to crown his restored rotunda at the Fifty-Eighth Street entrance. He finally found it right under his nose.

Ludmila "Lida" Turek, a fitter who worked at Bergdorf Goodman for forty-three years, tells the story: "The chandelier was made at a small factory

in Bohemia, to represent Czechoslovakia at the 1939–40 World's Fair in New York City. But it never made it to America, because the Nazis were bombing any boats leaving Europe. My father, who was a glassmaker and owned several factories, bought the chandelier and stored it in our cellar for many years.

"In 1947, I got married. My husband was a Czech diplomat living in Paris, and already there was a good possibility that he would one day become ambassador to the United States because he spoke perfect English. So my parents shipped the chandelier to us in ten cases as part of my trousseau, thinking it would one day hang in the Czech embassy in Washington.

"After the communist coup d'état in Czechoslovakia, my husband resigned. I convinced him to come for a visit to the United States. We never left. The chandelier was finally shipped to New York.

"I began to learn the business of dressmaking, because I knew I would have to be doing something useful—not just entertaining guests at state dinners. So I started making custom designs from our home, and then I went to work for Bergdorf Goodman as a fitter. That was 1957.

"Much later, when the Goodmans were renovating the store, and Mr. Goodman was searching for the right chandelier, a friend of mine told him about ours. The architect took one look at it and said, 'Perfect.' And that's how our chandelier came to hang in Bergdorf Goodman. I believe when the Goodmans sold the business, they specified that the chandelier was part of the building. It can never be removed."

In 1972, Bergdorf Goodman was sold to Carter Hawley Hale, and in 1987, it was spun off as part of the Neiman Marcus Group. Even today, Neiman Marcus controls only the business and the name. The Goodman family still owns the building, right down to its well-traveled chandelier.

The site is, quite possibly, the last family-owned block on all of Fifth Avenue. Amazingly, it has never been landmarked—not by the city, state, or federal governments, though it was proposed to the New York Landmarks Conservancy as a historic site in 2002.

Real estate maven Barbara Corcoran estimates she could list the property tomorrow for up to $2 billion and no one would blink. "There really are only two premier spots on Fifth Avenue," Corcoran

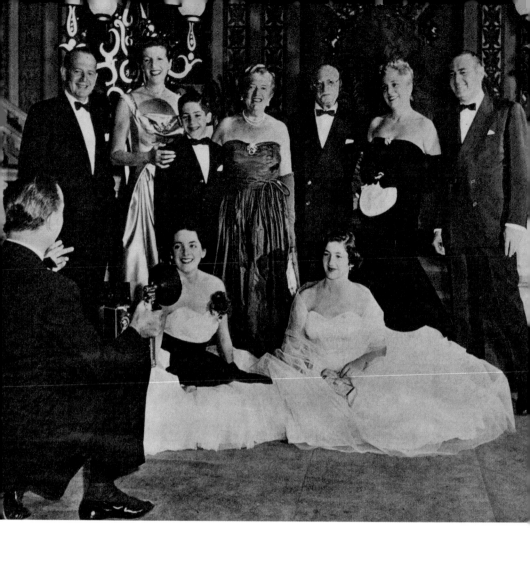

says. "One is the Plaza Hotel and one is Bergdorf Goodman, and if anyone ever touched that Bergdorf building, I think they'd be shot on sight. Because the truth of the matter is, it now belongs to New York." Or at least to the women of New York.

At any time, Bergdorf Goodman could have expanded with franchises all over the country, or even the world, but there is still only one store, in one city. "What's great about Bergdorf is that it hasn't changed—twenty Bergdorf stores didn't pop up all over the country," *Lucky* editor in chief Brandon Holley says. "It didn't follow the trend for more, more, more, which I think is very rare. Because stores seem to either shut down or proliferate like mad. And the fact that Bergdorf stayed where it was, as it was, is very special."

"The minute you try to replicate something, it's less authentic," Lauren Bush Lauren, whose charitable FEED bags are carried at Bergdorf, says. "The fact that this remains just what it is—it's quite beautiful. Even though styles change and trends change and this designer is hot one minute and out the next, it's nice to shop somewhere that has a feeling of permanence."

Opposite: The Goodman family at Bergdorf Goodman's Fiftieth Anniversary Ball, 1951, featured in *Look*. Back row, third from right: Edwin Goodman. Far right: Andrew Goodman.

"We are on the border of a new tomorrow," Karl Lagerfeld says. "Fashion is coming from the Internet more and more now. But a place like Bergdorf still has a reason to exist. There is nothing more appealing than to go to a beautiful shop, touch the things, see the things, try the things on, get it all in a beautiful shopping bag. It is like a cultural activity, something the Internet is not."

Princesses shop here. So do Hollywood's royals. But at Bergdorf Goodman, celebrity sightings rarely register a second glance (except for, perhaps, Lady Gaga, who went on a Christmas shopping spree sans pants). "As a woman, I just love shopping here," style expert Mary Alice Stephenson says. "You walk in and instantly get goose bumps. You feel the rush of what I think is the best kind of fashion. It makes you feel good, excited, inspired, aspirational. Even if you can't afford to wear it, you can look at it and you can be moved by it and see the art in it."

"Bergdorf is everything to a girl," Nicole Richie adds. "I've been shopping there since I was little. The main feeling that I get is that it is very welcoming. Of course it's a big store, but it really feels like a boutique. You just want to have fun in there."

Women feel so passionately about Bergdorf Goodman, they wouldn't dream of letting any major moments in their lives pass without marking them in some way there. They come to find just the right look to nail a job interview or to pick up a fantastic pair of shoes or accessory to enhance their confidence on a big date. They come to plan weddings—and a lucky few have even gotten engaged right inside the store. There are even women who have considered spending all of eternity tucked somewhere under Bergdorf Goodman's lovely mansard roof. Who can blame them? From the stunning views of Central Park to the awe-inspiring interiors to the impeccably selected luxury goods, it's a small slice of heaven.

BETTER THAN THERAPY

"My first trip to Bergdorf Goodman
was probably in utero, because my
mother shopped here all the time,
so I just can't remember not coming."

—Joan Rivers, comedian

Roughly 160,000 people visit Bergdorf Goodman at 754 Fifth Avenue each month. They come with their mothers, their daughters, their sisters and friends, to gossip, catch up, have their nails done, sip tea nestled into a hooded footman chair, or nibble a Gotham Salad while gazing out over Central Park.

But mostly, they come here to shop. Saks Fifth Avenue, Barneys, and Nordstrom might carry the same Marc Jacobs handbag or Manolo Blahnik pump, but buying those items from Bergdorf Goodman feels different somehow.

"Bergdorf Goodman has an audience that is a cross section not only of privileged New Yorkers, but tourists," says Harold Koda, curator-in-charge of the Costume Institute at the Metropolitan Museum of Art. "That kind of multicultural engagement is something you really only find maybe on Broadway in New York. It's an almost theatrical experience."

Slipping through the revolving doors and onto the parquet de Versailles is a transporting experience. That first glimpse of an exotic skin Akris tote or black diamond Lorraine Schwartz jewels, beckoning from their cases, is enough to hook most women for life.

Even something as simple as a pair of stockings becomes a decadent treat when it's tucked inside a lavender Bergdorf Goodman shopping bag. And the shoes, well . . .

"It's the most important shoe salon there is, probably in the world," George Malkemus, chief executive officer of Manolo Blahnik (and former Bergdorf Goodman copy chief), says. "I see women at Bergdorf who, after lunch, after they've had their hair coiffed, they're in the shoe salon, and they are captivated by the other women there, watching what they're trying on, asking for the same styles. When it's very busy, it becomes a feeding frenzy for footwear."

"I come to the store at least once a week," says Andrew Rosen, founder and chief executive officer of Theory. "I just like being able to check out what's going on, what the energy is on the floor, what people are reacting to, what Bergdorf is standing for, who they believe in. It's a great environment."

"It's one store on the planet where everyone comes to see what's going on," designer Narciso Rodriguez says. "To see accessories, the ready-to-wear, just the finest, most beautiful things. Whether you come to New York as a tourist or whether

you live here, it's the lightning rod that attracts everyone who's serious about fashion."

"We try to play down the intimidation factor, but it's hard to make it go away one hundred percent because there is some reality to it," says Burt Tansky, former president and chief executive officer of Neiman Marcus. "The entrances are narrow. The doors are small. It's not easy to flow in and out. We have a great many sales associates on the floor who move quickly to be helpful. It's not like a typical large department store where you can drift in and out, get no service, and spend most of the day there on your own."

"There is an intimacy to shopping at Bergdorf," Wendy Goodman, design editor at *New York Magazine*, adds. "The rooms are carved up into cozy spaces, so even though it is a very large store, you can keep wandering and going down different paths, discovering things, without ever feeling overwhelmed by the real estate."

If retail therapy exists, then this is as good as the analyst's couch. "It's one of the greatest places to get your medicine, if that's what you're looking for," says designer Lela Rose. No spoonful of sugar necessary.

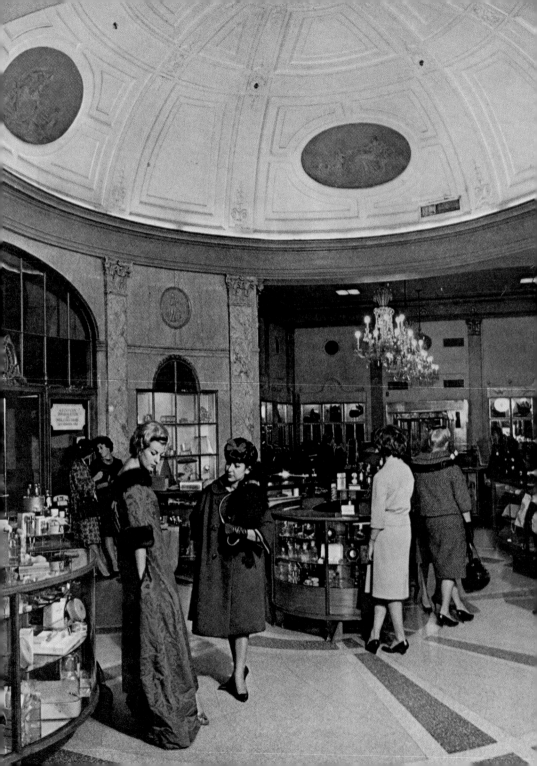

My mother was a great, prolific shopper. She always used to say that riding the elevator at Bergdorf was better than therapy. I think I was around fourteen or maybe fifteen, and we were shopping together in the shoe department, which was a favorite destination of hers. I picked out something like four pairs, and I wanted them all. I spent a lot of time debating, and my mother finally got sick of waiting—which, by the way, is a routine I am familiar with now that I have a daughter. So she said, "Oh, just get everything." And that was kind of it for me. I was bitten by the fashion bug, here at Bergdorf Goodman.

—**Kate Betts, contributing editor, *Time***

Right when I moved to New York, I met Eleanor Lambert, who started the International Best-Dressed List. I remember she told me that when she moved to New York, I think in the twenties or thirties, she would come to Bergdorf Goodman, and Mr. Goodman would be at the door to greet you. So I sort of always thought of it as old-school glamour. Part of me wishes that they had just made the store in the Vanderbilt mansion instead of tearing it down, but they retained the glamour, and the location can't be beat.

—**Mickey Boardman, editorial director,** *Paper*

I did my internship at Bergdorf Goodman when I was a student at FIT. There was an information booth at the Fifty-Eighth Street entrance, and I would have to hide and crouch down on a little stool and pop up as soon as somebody walked in and say, "Welcome to Bergdorf Goodman!" You could really startle these ladies if they weren't expecting you.

Lucille Ball used to come in to shop. She was fabulous. I remember there were all these jars of Imperial Formula lined up in a pyramid shape on the counter, and she would go to pull one from the bottom, joking to make us think the whole sculpture would collapse.

I was also a Christmas angel not long after I started. These were young girls who would stand at the front of the store, and people—usually gentlemen—would come in and give you their shopping lists. And you would say, "I'm your Christmas angel. How can I help you?" That wouldn't be very PC today.

—**Candy Pratts Price, creative director, Vogue.com**

I first went to Bergdorf because I was doing a *Vogue* story on John Barrett, the British hair designer, and his salon was on the top floor. So I didn't actually buy anything. I don't think I would have gone there to shop for myself at the time, age twenty-seven, having just arrived in New York.

This was 1997 or '98, and it was all about the Miller sisters, Carolyn Bessette-Kennedy, Gwyneth Paltrow—these gorgeous blond American girls. It was really chic at the time to have that white-blond hair, ironed perfectly straight. I got to New York and thought, "I'm so brunet, and everyone here is so blond." So I went to Bergdorf and dyed my hair and wrote about it for a story called "Chasing Goldilocks" in *Vogue*.

— **Plum Sykes, author, *Bergdorf Blondes***

My earliest memory of Bergdorf Goodman was my mother making these caftans and tunics for a woman by the name of Lorraine Clair. My mom was a dressmaker, and this woman had found my mother and asked her to make these caftans and tunics with a hand-painted silk. She sold them at Bergdorf Goodman.

I was just a kid. I had no idea what Bergdorf Goodman was, but at some point, my mom wanted to come in and see the stuff that she made, hanging on the racks. So I came in with her. She told me rich people shopped there.

As a customer of Bergdorf now, I've found that it's one of the only places that I don't mind paying retail. The editorial viewpoint that the store's putting forward is really on point, and you know there are not going to be a lot of these pieces. There's usually only one in my size. And if I don't get it, someone else will.

—Robert Verdi, stylist

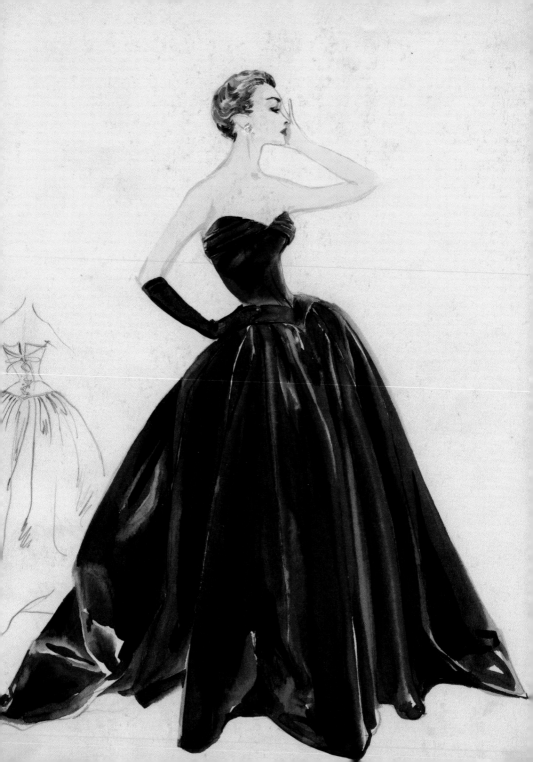

BERGDORF
GOODMAN

EXCLUSIVELY OURS TOM FORD View the Fall Collection. Second Floor. 212 872 8793.

My sister and I began working at a really young age, and we would often travel to New York. We always had a lot of women around us, so whenever we ended up with a little break, we would go to Bergdorf Goodman. I remember it was a special experience for the woman we were with, going to the shoe department. We were probably about five or six at the time.

As we got older, the shoes were the first things we could fit into. We started to hit the five, five and a half, six size range, and it was exciting to actually start to try things on. Because up until then, we were so young and petite, it was kind of hard to shop here.

—Ashley Olsen, designer,
The Row and Elizabeth & James

P eople go crazy at the shoe sales. There are e-mails flying. I'm getting calls, "Did you go over there? What did you see?" You don't even have time to talk to your friends because you want to go and get the shoes before they do.

I have been at Bergdorf and seen women seated next to the Mount Rainier of stilettos—just piles and piles of shoes they are buying because the deals are so fantastic. It's really kind of funny because you see all these very smart, sophisticated, gorgeous women acting like little kids. They're sixteen again, like, "Oh, I've got to grab that shoe."

Women in New York can't have enough. Their closets may be the size of postage stamps, but their shoe collections are enormous, and they're buying them at Bergdorf Goodman.

— Mary Alice Stephenson, style expert

Page 54: Balmain gown, fall 1951, original sketch rendered by Bergdorf Goodman. Page 55: Bergdorf Goodman's Tom Ford advertisement for the *New York Times*, fall 2011.

One of the first times I came to Bergdorf Goodman, it was very busy in the shoe salon. I saw this woman who was wasn't getting help because all the salesmen were so busy. So I thought, "I'm going to help her." I said hello. She didn't know who I was.

I confess: I was slightly pushing some of my shoes as she looked.

She told me I was a good salesman. "I've never seen you here before," she said.

I told her, "Well, you know. I'm just new here. This is my first day."

Once she had the styles she liked, I found someone from Bergdorf, and I said, "I actually have someone over there who would like to try these styles." Because I couldn't go into the stockrooms—I didn't know where they kept the shoes. Then I disappeared, because there wasn't much more I could do for her. She did buy some shoes. I just hope I wasn't rude, leaving her that way.

—**Christian Louboutin, designer**

I spent my very first commission check of $340 at Bergdorf Goodman. It was 1974. I was twenty-three at the time. I shouldn't have been spending the money, but I ran my butt right over to Bergdorf, went up to their coat department, intimidated like crazy by the way those ladies handled me, and I spent the whole $340 on the fanciest coat I could find.

The coat was god-awful, frankly. It was probably the only ugly one on the whole floor. But it cried out for me. It had a mandarin collar with some kind of dog hair and went all the way down to my ankles. But I was so fancy in that coat, walking up and down the streets of New York.

— Barbara Corcoran, real estate entrepreneur

When I was in tenth or eleventh grade, we took a trip to New York with my boyfriend's parents. We went to Bergdorf Goodman—it was the first time I had ever been to the store.

I was totally in awe. I just remember the exterior and this beautiful, grand, incredibly classic building . . . all the jewels . . . and the richness of it . . . It was mind-blowing.

About four months later, I bought a dog for my boyfriend, a Dalmatian, and I named him Bergdorf.

I know it sounds bizarre. But it's really incredible that, so many years later, I designed the BG Restaurant. In a million years, I never would have thought that would happen.

—Kelly Wearstler, designer

One time, there was a mother and a daughter who came to Bergdorf and bought the same dress from my collection. That was really kind of fascinating to me.

I've had clients who are seventy-five or eighty here, trying on coats of mine, next to women who are a quarter of their age. For me, that's really cool, having older customers who are willing to try something new from a young designer and, of course, reaching the younger set at the same time. That only happens at Bergdorf.

—Thakoon Panichgul, designer

My mom was a model in New York, so I saw Bergdorf boxes before I could walk. She loved Bergdorf because it had a cachet of chic that no other store had. And that has continued, which is really shocking.

My own daughter was two and half weeks late being born, so I was huge—I had put on sixty pounds and had to wear muumuus. I was Shamu the Whale. And I used to lurch through Bergdorf— at the time, I lived just up the street. One day, I noticed another shopper looking at me sort of quizzically and finally she came over and said, "You know, you have Candice Bergen's face."

I later brought my daughter here for her first winter coat. And we got her prom dress here. It's really fun to come in with her. We skulk around the fifth floor and then go to lunch.

—**Candice Bergen, actress**

Opposite:
"One Thousand
Vintage Barbie
Outfits," store
window, 2011.

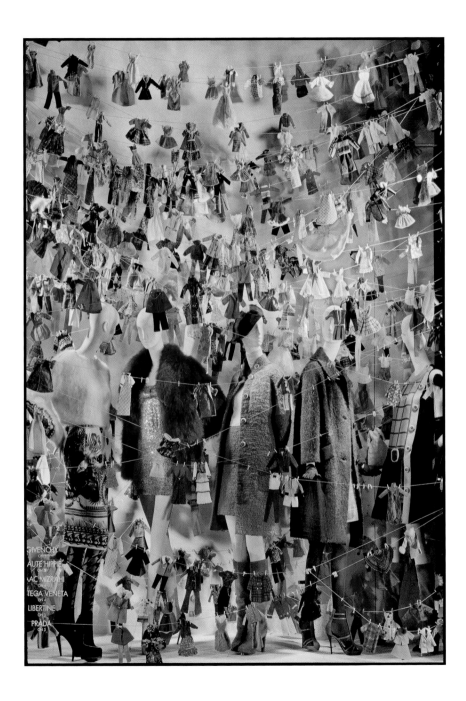

I really don't know when Bergdorf entered my perception because my mom would bring me here on outings. There used to be a doorman at Bergdorf who would park her car. I'm not kidding. My mother would come and leave her car, and this guy, whoever he was, would watch it. For the whole day. And she wasn't some crazy-rich customer. She was a bourgeois lady from Brooklyn!

I do remember there were all those great hats, the Halston hats, and the Emeric Partos furs. Most people don't know that name, but to me, Emeric Partos was a god. This was a man who could make anything out of fur—knickers, capes, hats, all the outfits Barbra Streisand wore in *My Name Is Barbra*.

My mother used to describe expensive clothes as "small," and the woman who wore them were "fine-boned." You would see these almost ghostlike silhouettes walking through Bergdorf. They were so faint, they would float across the aisles. And they were always covered up. They wore hats and glasses and wigs. Women were incognito when they shopped in those days. People didn't like to be caught in the act.

The great lesson of my life was walking into Bergdorf and seeing just the stillness of it, the silence of it, the elegance of it. Today retail is not about that. It's about loud noises and giant displays. Everything is at huge decibel levels. But when I was a kid, somehow when you walked into Bergdorf, you just felt that everything would be okay. Like if there was a hurricane, or an earthquake, or a tsunami, if you were at Bergdorf Goodman, you would be just fine.
— **Isaac Mizrahi, designer**

I was thirteen when I first visited New York— it was for a birthday trip. When my mom and I went to explore the big city, she said, "You need to know two words: 'Bergdorf Goodman'."
— **Edward Bess, founder, Edward Bess cosmetics**

What I remember most is coming with my mother and having a sense that I was about to meet somebody very important, because she took me to see the Bergdorf Goodman fashion director, Ethel Frankau. This was in the fifties.

There was great ceremony to it. I remember the furniture, all the settees in Ms. Frankau's area. It felt like we were in a private living room. It was very quiet. There was a lovely kind of reserve to the space. Models were walking around wearing dresses to demonstrate fit. It was all very exciting for me as a little girl.

—Wendy Goodman, design editor,
New York Magazine

My best Bergdorf moment was when I came here with my mother as a child. I was seven years old and we were at Carnegie Hall, being photographed by Carl Van Vechten, and we decided to walk through Bergdorf Goodman.

I stepped inside, and I was instantly grounded. The lighting, the chandeliers, the glass cases, the high ceilings—when you're tiny, everything is very big. And I thought, "This is something very special."

So that was my first experience. Then my mother and I went to the Plaza for tea.

—Pat Cleveland, former model

I was born and grew up on the Upper East Side and Bergdorf Goodman was a part of my weekend life. My mother and I used to come all the time, so I spent many a Saturday here.

When I was very young—I must have been about seven years old—we were up on the children's floor, and I remember my mother purchasing a beautiful white rabbit coat for me. And the Goodmans actually came down to see me and to greet us. So I remember a very distinct meeting I had with Mr. Goodman and his wife. That's one of the most special memories I have of Bergdorf Goodman.

The store has been a multigenerational experience in our family. Three generations of women have shopped here.

—Vera Wang, designer

My earliest memories of Bergdorf Goodman are from when I was a very small child. My mother would come here during her lunch breaks from Estée Lauder to buy me these beautiful little smocked dresses, and I always remember her coming home with them wrapped up in pretty lavender bags. We grew up very close to Bergdorf, so this was a natural place for us to come shopping together. I would shop for contemporary clothes and she had her designer favorites. So we both left happy.

— **Olivia Chantecaille, creative director,**
 Chantecaille cosmetics

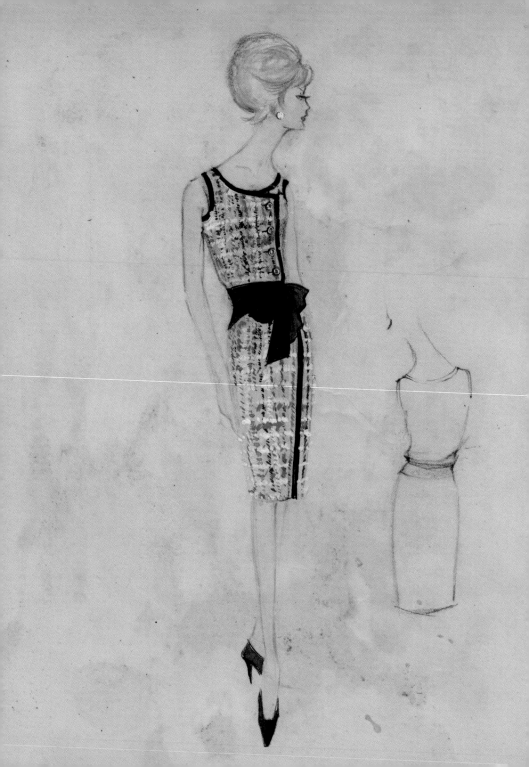

BERGDORF
GOODMAN

ENCHANTING *since 1901*

VALENTINO
View the Spring Collection
Fourth Floor 212 753 7300

Certainly, growing up in Garden City, a suburb of New York, I had heard about Bergdorf Goodman. It was like the Emerald City. It was Oz in New York in terms of shopping.

My first experience here was picking out my bridesmaids' dresses. The bridal salon of Bergdorf Goodman was a very exciting place for a twenty-two-year-old girl. I had just been living here for a matter of months, and to me, Bergdorf was magical. The store itself is so quintessentially New York and certainly what I dreamed it would be, with all the detail, the moldings, the high ceilings, the aura that I felt coming in. I had looked in all the different stores around town, but I just simply liked the bridesmaids' dresses at Bergdorf best.

I got married in September and the dresses were an apricot/peachy color. They were silk brocade, very simply cut, long, and beautiful. You hear such nightmares about bridesmaids' dresses, but my bridesmaids were very happy.

— **Susan Lucci, actress**

I had a woman come in at least fifteen years ago. She was heavy but her friends were all slim, and they told her to come and see me. She walked in with great trepidation.

I have a certain set of questions that I ask clients on the phone first, which usually gives me a very good idea of what to pull for them. This happened to be a year when I had a lot of things that would work for her particular size. So I found her many beautiful clothes.

Once she was in the dressing room, I had to leave for a moment, and when I came back, she was standing there crying. Feeling guilty, I said, "Oh my god. What did I do? Are you all right?"

And she said, "You have to understand. I came here thinking that you were going to look at me and say, 'I have nothing to sell you. Go home. You're too heavy.' And now you've got more clothes for me than I can afford to buy."

That, to me, was more meaningful than selling $100,000 worth of jewelry—not that I don't like selling $100,000 pieces of jewelry.

—**Elaine Mack, personal shopper**

Page 70:
Chanel dress, spring 1965, original sketch rendered by Bergdorf Goodman.
Page 71:
Bergdorf Goodman's advertisement for Valentino, the *New York Times*, spring 2011.

My daughter and I both work at Bergdorf Goodman.

She was very young when we emigrated from Russia to the United States. I was trained as an engineer, but I always loved fashion. My first job in this country was to do manicures and pedicures. My parents were very comfortable in Russia, and we used to have a lady come to my house to do this for us. But I needed a job, so I went to a salon on Park Avenue—not Queens or Brooklyn—and they took me right away.

After about six months, the owner said, "You're too good for this. You're too bright. You have to go do something else. I'm going to give you a whole day off. Just go and find a job."

I said, "Are you firing me?" And I started to cry.

He said, "No, I'm not firing you. I just think you can do better."

So I went to Saks for about four months, and I should probably not say this, but I hated it. I was just a number to them. They never knew my name.

Then I came here to Bergdorf. I started in Fragrances and Cosmetics. After a few months, I asked around, "How much does a top sales person

produce?" I watched, I learned. In a year, I beat that number. Then I moved to the Chanel handbags department, then upstairs to the Chanel boutique, and then they asked me to become a personal shopper. I've been here thirty years.

— **Alla Prokopov, personal shopper**

I would often come here to Bergdorf when the rest of my class was on a field trip. My mother would say, "Come to the store instead. You'll learn more." Because usually the field trip was to the zoo or something, and I'd already been.

So I'd come to the store, and I just remember sitting in the cash wraps on some cardboard box or a footstool. And I would either have a coloring book with me or my homework. But most of time I ended up sitting there, watching the sales associates and the customers.

It always smelled nice and there were always pretty people around and everybody was always dressed so well—just heaven for a little girl.

— **Karina Prokopov,**
 couture eveningwear manager

I n 2007, I got a call from Linda Fargo [senior vice president of the fashion office and store presentation] at Bergdorf Goodman. She asked if I would be interested in designing their new restaurant. Of course I was thrilled. I went to New York for a visit and saw the space, which wasn't a restaurant then. It was a shopping area for home objects and china and books. But it was a beautiful space, overlooking Central Park.

I wanted it to feel very fresh, but classic—that it respected the architecture and the history of Bergdorf Goodman. But it also had to be fashionable and a place someone who was twenty or ninety years old would appreciate. So that was challenging.

In designing the concept, I came up with the idea of a series of salons, because that's how Bergdorf feels, with the various salons for all the different fashion designers. So there's the bar area, then you move into the main dining room. In the back, there's what feels like a private salon.

When you're in the room, looking out those amazing windows and seeing the trees of Central Park, the colors work with that view. They had to have a dialogue.

My first concept did not look very much like it does now. I had everything a beautiful cinnabar color that was just very rich and masculine, very cool and sexy. But it was heavy. Linda Fargo and Jim Gold [president of specialty retail, Neiman Marcus Group] felt the space should have a lighter palette. So then it was pink and green, which I really loved. But with the restaurant having so many different clients, that wasn't quite right either.

Everyone loves blue. Men love blue. Women love blue. Children love blue. It just feels happy, and it can be sexy and fresh and modern and classic all at the same time. So we used a robin's egg blue, and then a really beautiful bone color with gold leaf and ebony detailing, and then a citrine—this beautiful yellow.

The whole process took about a year. We spent three or four months on schematics and concept design, and then there were the drawings, all the detailing, and, of course, the construction.

I've had many meals there since then. Looking back, it was one of my all-time best and favorite projects.

—Kelly Wearstler, designer

When you go up to the BG Restaurant, it's like walking into a Hollywood Regency fantasyland. It's gorgeous. It overlooks Central Park and the Plaza. When you enter, you're immediately a part of the scene, the buzz. There's this energy there. I don't think that happens in most restaurants that are known as haunts for ladies who lunch.

I love going there, because as a person who doesn't have an office, the restaurant becomes my office. I can go there supposedly for lunch and not leave until six o'clock in the evening. Because I will just have meeting after meeting, and sometimes they are unexpected impromptu moments. You run into someone and say, "Why don't you sit down? Let's have some tea." And then you run into someone else and it's, "Sit down. Why don't we have some wine?" And then before you know it, it's six or seven o'clock and you've been at BG since noon.

—Bevy Smith, social media socialite

Sometimes people make fun of the lady who lunches, but, frankly, that's our customer. That's the girl I like. She's dressed. She looks great. She's got on her heels. She's out and ordering a teeny little salad. There are definitely a lot of ladies who lunch who go to Bergdorf, but it doesn't mean that it's such a rarified place to eat. It's just a place to go where you feel like you're going to see some high fashion. I so appreciate that over someone who is always in sweats or jeans, who doesn't feel like they need to make an effort and put on something fun for the day.

—**Lela Rose, designer**

I like Gotham Salad so much that even when I don't eat at the BG Restaurant, my assistant goes and gets it for me and brings it to my office.

—**Santiago Gonzalez, president and creative director, Nancy Gonzalez**

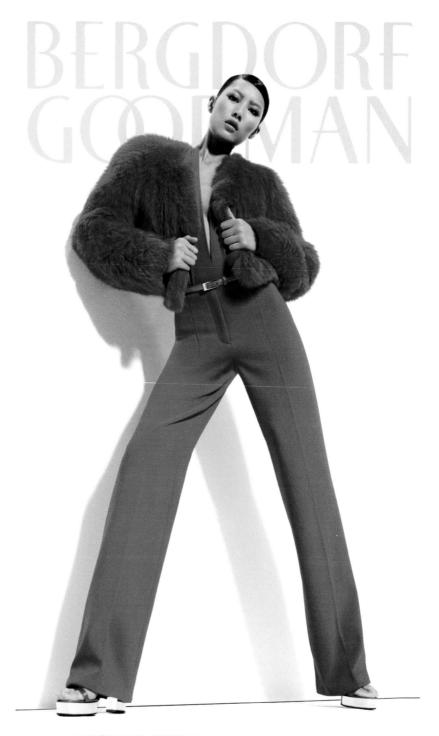

MICHAEL KORS CELEBRATING 30 YEARS AT BERGDORF GOODMAN

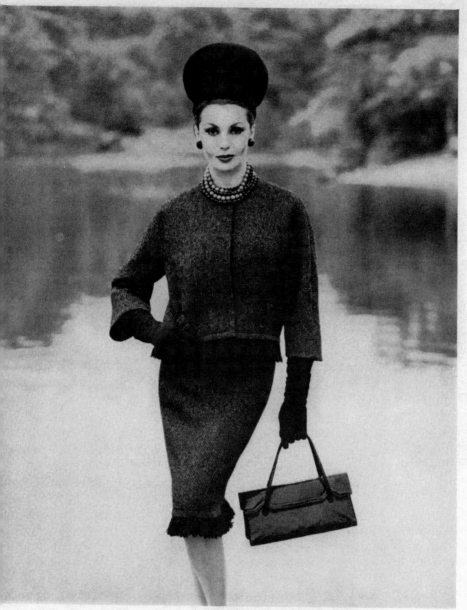

YNOCENCIO

Instant Pepper *exclusive at $310*

Now generating its own excitement — the tweed that's stepped-up with plenty of pepper. And Christian Dior-New York heightens the flavor with thick black fringing on a bright, brisk suit. Its shape — freewheeling, non-conformist. Its scope — anywhere in the world. Imported wool tweed in black-peppered grey. Sizes 8 to 14. Exclusive at $310. Suits, Third Floor

ON THE PLAZA · NEW YORK 19

BERGDORF GOODMAN

5TH AVENUE AT 58TH STREET

There are certain people who have certain tables they like or that they must have. We get requests for different seats, and so every morning, we set the stage with that. Oftentimes, we'll have a luncheon in the back of the dining room. It can be maybe thirty people. Or a birthday party, a baby shower, or a wedding shower—those are always very fun, festive.

The peak is usually around one to two o'clock for lunch. Everybody wants to be recognized, they want to be flattered. Some of these ladies really knock themselves out, especially if they're meeting girlfriends. It is a place to doll up and get glamorous. We try to handle everything as smoothly as possible. We may have a lady who always likes a certain corner table, but then as we're walking her to that table, she'll see someone nearby and say to me very quietly, "Oh, I can't sit here today, dear. Put me as far away as possible." And without seeming like we're out of step at all, we just casually go right by and take her to another corner of the room, out of sight from whomever she doesn't want to be seen with.

Sometimes, you'll overhear something. The lady might mention something to her girlfriend: "I can't

believe that she's here today." And you can piece together the backstory. We get so many customers who we become friends with and who share with us all the dramas in their lives.

—**Michael Perricone, director, BG Restaurants**

When my girlfriend, Alexis, and I first started dating, we were spending a lot of time in New York because I had an apartment there. And we would look out at the Bergdorf windows and talk late into the night about them, how we'd re-create this or that in our own lives. "I want to live in that room. I want to dress this way."

When I decided to propose, I wondered if I could get Bergdorf to do a window just for us, so we could have this magical environment all to ourselves. And so I called Pamela Fiori [former editor in chief of *Town & Country*], and she put me in touch with Linda Fargo at Bergdorf, and I said, "You don't know me, but I'm Trevor and I have this idea."

She said, "That's not possible. I don't know how the store will feel about it." But I was persistent,

Page 80:
Bergdorf
Goodman's
advertisement
for Michael
Kors, the *New
York Times*,
fall 2011.
Page 81:
Bergdorf
Goodman's
advertisement
for Christian
Dior, *Vogue*,
September 1960.

and finally, she said, "Well, let me call you in a couple of days." She did call back and she said, "You know, I talked to the brass here and they're willing, but I think a window will be too small. It'll be too hot in there with the lights, too cramped. It's just not possible. But there's a little room inside the store—we call it the rotunda. I've always had a fantasy about doing something special in there. This is the perfect occasion."

There was a lot of brainstorming that went into it. We only had two weeks to pull it together. Linda found this incredible Venetian grotto table and chairs and we talked about all the things that would go onto the table.

Alexis is the creative director at her family's vineyard in Napa, and they have a line of wines called Alexis, and I wanted a bottle of her wine there. They also do caviar. So I had some of her caviar and her chocolate shipped to New York, and I had to sneak over to Bergdorf to meet with Linda. She choreographed this entire event for one night only, and then had to have it all cleared out by the next day. The store had to be the store again.

On the night of our engagement, I told Alexis I had a dinner reservation for us. I was in jeans

because I didn't want her to suspect that anything was going on. Meanwhile, I had the ring in one pocket and her nightgown in the other. Oh, and my Prilosec. That was what I brought: the ring, the Prilosec, and the nightgown.

We took a carriage ride through Central Park. It was drizzling. The doorman at Bergdorf was outside with an umbrella and he welcomed Alexis by name and opened this little box with a key, which of course opened the door to the store.

We walked into this beautiful room. They had removed all the handbags from the rotunda, and in each of the alcoves was a nest for birds or a little something special to look at, painted peacocks and things. They had strung flower petals from the chandelier and there were candles everywhere and orchids. It was all so sensory, with the candles and the fabulous grotto table and chairs. And what was so perfect and precious about it was that, like some sort of midsummer night's fantasy, it would evaporate. You knew it was there for an hour, and then it would go away. No one else would ever see it again.

—Trevor Traina, technology entrepreneur

When I first walked into the store, I had no clue what was going on. I turned to [Trevor] and said, "Did you win this in some sort of charity auction?" Then he got down on one knee and proposed.

Linda had only promised him an hour, but we were there more like two or three. We sat and had this feast, ending with a mille-feuille cake from Lady Mendl's Tea Salon.

After Trevor proposed, I wanted to know, "Who did all this? How did it come about?" And then magically, there was Linda. We all embraced, and I said, "Tell me about your team."

And Linda said, "Team! Team!" And out of the shadows came god knows how many people. They were all there to help pull this off, and they were just as excited as we were.

What we didn't know was that they had painted our initials onto one of the windows on Fifth Avenue, so we could see it as we were leaving for our suite at the Pierre. In the end, we got our window after all.

—Alexis Traina, creative director,
Swanson Vineyards

wanted to create an enchanted forest for them. We even had a soundtrack playing of exotic birds. We all stayed in the building, and I confess, we snuck around the corner, listening as hard as we could—basically eavesdropping. But we couldn't hear a thing. We couldn't hear him proposing. We couldn't hear what she said. And we were like, "Why did we have those damn birds?"

But it was very romantic. And Trevor was impossible to say no to because his enthusiasm and his passion were just infectious. We've never done anything like that for anyone before or since.

—**Linda Fargo, senior vice president of the fashion office and store presentation**

BERGDORF
GOODMAN

DYNAMIC *since 1901*

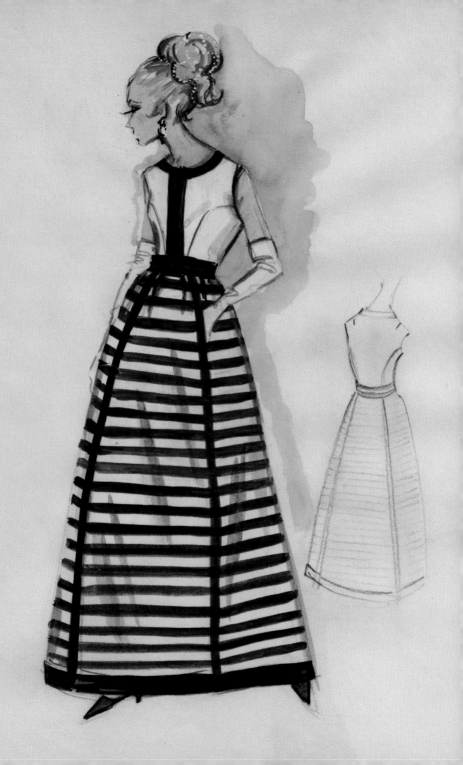

I remember one time we were doing something over the top insane in the evening department—we had a dress made in, like, two days, shipped to the customer, which required jumping through all these hoops. So I was upstairs in Client Services a lot, and one of the women there said to me, "You know, don't worry. This is nothing for us." And then she told me a story about a bride who was getting married who had ordered her dress from Bergdorf Goodman. Something went wrong. The bride called in a panic, and the store had to send a new dress out to the wedding in the Hamptons.

This was in the middle of summer, so there was traffic and they couldn't risk sending the dress with a driver. So the store hired a helicopter and flew the gown out there to make sure that it got there in time.

—**Karina Prokopov,**
 couture eveningwear manager

n two cases, I was part of divorce settlements. Both women were huge clients of mine and both of them were getting divorces and they weren't going to be able to, well, shop the way they had in the past. So as part of the legal agreements, each of them got one last gigantic shopping spree at Bergdorf, after hours.

I do remember selling one of the ladies an extraordinarily fabulous jacket during her final visit. She told me it cost more than her first car.

—Elaine Mack, personal shopper

Page 88: Bergdorf Goodman's advertisement for Givenchy, the *New York Times*, spring 2010.
Page 89: Balmain gown, spring 1966, original sketch rendered by Bergdorf Goodman.

I stopped seeing a gentleman, and I was very depressed, and I came into Bergdorf and went right to the good jewelry department. I bought these gorgeous topaz and gold necklaces. It's amazing because I still have the necklaces. No longer have him, but those topaz and golds get pulled out all the time. Retail therapy? Absolutely works.

—Joan Rivers, comedian

I have a client who was shopping in Bergdorf, and she completely lost track of time. She was just going through the racks, and all of a sudden, she said, "Oh my god, it's eleven o'clock at night. The store is closed." She realized all the doors were locked.

But she didn't panic. She said, "You know what? What a better thing than being by myself at Bergdorf? I'm just going to shop and try new things." So she went on until probably one o'clock in the morning, trying on the clothes. And at some point, she got a little scared because nobody was looking for her. She finally saw a man walking, I think, with a dog. And it was security.

But the security guard was terrified because he thought he was seeing a ghost! He settled down and helped her out of the building. The day after, she came in and bought everything she had tried on the night before. But she said to me, "You know what? I was so happy. For once the store was mine."

—Roberto Faraone Mennella, jewelry designer

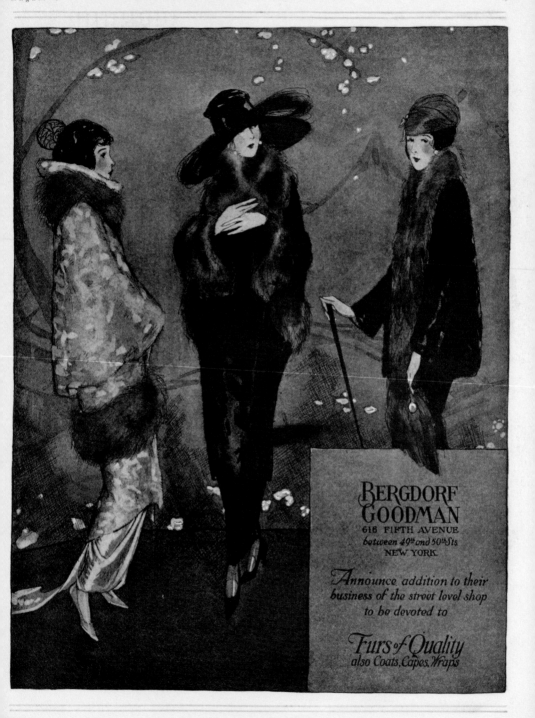

BERGDORF
GOODMAN
618 FIFTH AVENUE
between 49ᵗʰ and 50ᵗʰ Sts
NEW YORK.

*Announce addition to their
business of the street level shop
to be devoted to*

Furs of Quality
also Coats, Capes, Wraps

A t one point, the fur department moved from one side of the second floor to the other, and we had a separate little Fendi boutique for furs, which was new. And we didn't really have a vault. So at night, we would take in all the expensive Fendi coats to a stockroom closet. The door would just sort of lock behind you. There was no bolt. But that's where we kept the Fendi furs at night.

Every morning I would come in. I would open that door, and I would set up the salon. Well, one morning I open the stockroom door, and there are no furs in there. I said, "Guys, what's going on? Where are the furs?"

We found out what had happened from someone who was staying in the Plaza Hotel the night before. They looked out and saw the windows at Bergdorf Goodman were open, and somebody was throwing fur coats down to the street below, one by one. And another person was down on the street, catching them and tossing them into a van.

I don't think the police ever caught the thieves—I can't remember if they did. But there were about fifteen coats taken. They even threw some mannequins wearing furs out of the windows.

Opposite:
An advertisement
for Bergdorf
Goodman, *Vogue*,
August 1919.

Later on that day, we found those mannequins in Central Park with the furs still on them, attached with security devices, because that's how we displayed them. The burglars left them in the grass, and we did get those back.

—Jack Cohen, former fur department buyer

I remember one Saturday, I was home in bed, and I got a call from the store: a royal was coming in and they expected me to have some clothes ready for her. I lived in the suburbs then, which meant not only getting dressed, but making it to the train on time.

So my husband comes home in the middle of my frantically rushing around and says, "Where are you going? And why are you getting so dressed up?"

I said, "I have to go to work."

He said, "Today? It's Saturday. Who's so special that you have to go to work on a weekend?"

And I said, "Well, the Queen of —," and he laughed. And I went in.

This particular queen came dressed incognito, in blue jeans, a crepe blazer, with a hat pulled down over her head. But she had all these burly security guards with her, who were kind of hard to miss. I had clothes in the room ready for her, but she said, "I have to walk around. I'm dying to walk around this store."

Well, the security guys were not happy about that. They had to stay right with her. And so here she's dressed incognito, trying to have a normal day out shopping. But there are these nine-foot-tall guys with earpieces in following her around the store.

We went from floor to floor, because that's what she wanted, and I was happy to oblige. And all the while, those guards were trying their hardest to be inconspicuous, going through boutique after boutique of ladies' clothes, pretending to look at little delicate dresses and things, when they were really keeping their eyes on her.

— **Elaine Mack, personal shopper**

I needed some stockings. I was running to rehearsal for a special, so I ran into Bergdorf and got up to the lingerie department.

Nobody was there. It was pretty empty except for the saleslady. She came up and she was so sweet. She said, "Hello, Miss Burnett. It's so nice to have you. What can I do for you?"

"I need some stockings."

"Of course." Then she had me sign autographs for five of her grandchildren, which I was happy to do and all.

Then it came time to pay and I didn't have the right credit card with me. I said, "Oh, gosh. It's back at the hotel. Could I write you a check?"

"Well, I'll need some identification."

I said, "But you know who I am."

She said, "Oh, I know that, but we need your driver's license and we have to write the things on the check. Wait a minute. Let me go check with Miss Carlton, who is the floor manager." She's this lovely lady clear across the floor—still empty—at a desk. This lady went over there to that lady, whispered, whispered, whispered, waving back hi, and I'm waving back.

Finally, she comes back. She says, "Miss Carlton will approve your check if you'll do the Tarzan yell." Okay, at Bergdorf Goodman, I'm gonna do the Tarzan yell? So I did, and it was a doozy. From the back of the room, the exit door burst open and there was a security guard with a gun.

So now I only do it under controlled circumstances because I don't want to give anybody a heart attack or get shot.

—**Carol Burnett, comedian, on** *Tavis Smiley*,
 PBS, April 30, 2010

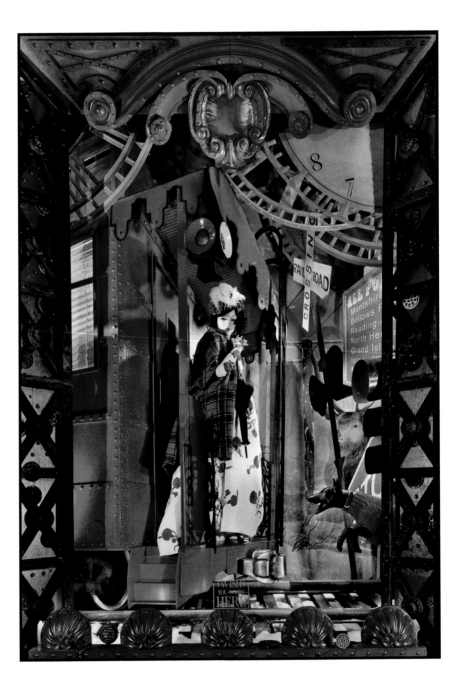

I was really new to the store and working on the third floor. This was in 1977 or '78. Carol Burnett came in and wanted to purchase something but didn't have any ID with her, and she wanted to pay with a check.

So I checked with my manager and got the okay, and I go back to Carol Burnett, and I say to her, because I have a pretty good sense of humor, "You know I can do this for you, but you have to prove to me that you're really Carol Burnett. I want you to do the Tarzan call."

So she did it right in the store, and it was hilarious. Everybody was looking and laughing and it was really funny, and then she paid and we gave her the item and that was it.

Well, when Carol Burnett tells that story, she says that a security guard came running over, pulling his gun, because he heard someone screaming. She claims that's why she never does the Tarzan call anymore. But between you and me, I don't think our security guards even carry guns.

— **Carole Wasserman, sales associate**

Opposite:
"The Scenic
Route," holiday
store window,
2010.

NOTORIOUS
SHOPPERS

"Almost every guy I meet says,
 'It's nice to meet you, but you have
 cost me a fortune. My wife must
 be your best customer.'"

—Jim Gold, president of specialty retail,
 Neiman Marcus Group

I f a simple trip to the Bergdorf shoe salon can induce an endorphin rush in most women, just imagine being able to shop the store after hours? What about having Bergdorf Goodman brought to you?

When certain customers come in, they get whatever they want. And some of them don't even need to come in.

"There's no price resistance," Michael Bastian, menswear designer and former Bergdorf Goodman men's fashion director, says. "When I first started working here, I would do reconnaissance work in Italy, going to designer showrooms and tailored clothing companies to find new labels. But I didn't know if a five- or six-thousand-dollar sport coat would fly in the store. The head of my department quickly set me straight. 'That six-thousand-dollar sport coat to them is like you or me going to a supermarket and buying a bag of Oreos,' he said. 'There's no long, dragged-out mental process of "Can I afford that?"'"

Of course, the shopper who can have it all has also probably seen it all, and can therefore be difficult to impress. "There are these women who

come in the store every single day," jewelry designer Amedeo Scognamiglio of Faraone Mennella says. "All the time, we have to change what's in our counter, because they stop by and want to know what's new. Whatever we show them, they say, 'Seen it,' or 'Own it . . . What else do you have?'"

Hard-to-please customers keep the staff on point—something that benefits everyone who shops at Bergdorf. After all, you don't have to be an heiress or a mogul to enjoy looking at a finely tuned selection of rarefied goods gathered from all over the world, and every customer gets VIP treatment. There's almost nothing Bergdorf Goodman won't do for you.

Opposite:
"Subway Twister,"
store window,
2006.

right hand - R train

THE NEW YORK CITY
DEPARTMENT OF
TRANSPORTATION

www.nyc.gov

MISSONI ON 4

staten island ferry · subways · traffic · railroads · signs · taxi & limousine commission · streetlights · s

I remember we were having a pretty difficult season selling furs one year in the seventies. The phone rang on Christmas Eve at about four o'clock. It was Yoko Ono, asking me to come to her apartment. John Lennon wanted to buy some furs for her.

I said, "You know, it's Christmas Eve. We're closing early. I'm not sure I can arrange it." But I made a few phone calls and Ira Neimark, the CEO at the time, told me to do whatever I had to do to make the sale. So we booked a car, got a couple of security guards, and pulled eighty-eight fur coats, packing them up in huge salesman sample boxes.

It was really very cold that night as we trekked up to the Dakota. We had to carry everything by hand up from the underground garage because all the valets were gone for the Christmas holiday. So we loaded everything into the service elevator and went to the back entrance of the Lennon apartment. On the door, there was big oval brass plaque engraved with the word "Utopia." And I thought to myself, "Typical."

We rang the bell. Yoko was very happy to see us. After all, she hadn't bought furs in a few months, so she needed something new. "Come on in," she said, "but take your shoes off first." There must have been

twenty-five sets of china in their enormous kitchen, and there was a ton of electronic music equipment.

We went in, and Yoko very excitedly started unpacking one of the boxes. She took out a Fendi fur, tried it on, and said, "Oh, I love it. It's fabulous. But hold on, I want John to be a part of this."

John came in and greeted us. He asked if we'd like something to drink, and suggested we make ourselves comfortable in the living room. Yoko took us down a long hall. There was very little furniture, but many of the rooms had these crystal and geode pyramids. Yoko was really into healing and quartz and all of that stuff.

There was a huge white grand piano in the living room. I remember it was really hot, because they had the heat cranked. Yoko left us there, still waiting for that drink.

This was before cell phones, so I couldn't even call my wife to let her know what we were doing or what time I would be home on Christmas Eve. We sat in that room for a good two hours. And at one point, I looked over, and in the corner there was a sable coat balled up on the floor—it was a coat I had sold Yoko recently, just sitting there in a heap.

Yoko finally came back and said, "Jack, come with me. I have a surprise for you."

We followed her back into the kitchen. John had disappeared, and all of the trunks were just as they were when we brought them in. Nothing was out, except for the one fur that Yoko had tried on in front of me. And I thought to myself, "Well, her surprise is going to be that she's buying nothing but this one fur coat." Which would have made me a little angry and disappointed, considering we'd come all this way on Christmas Eve.

She said, "Sit down. I'm going to open a bottle of wine." Then she goes over to the first case, takes the lid off, and says, "Well, the jacket over there I'm buying because I loved it immediately, and I'm going to buy this one and I'm going to buy this one," she said as she started pulling out coats from the trunks. "And John's going to buy this one. And I'm giving this one to John's sister. And I'm giving this one to my sister. And I'm going to take this one. And John's going to wear this one." It just went on and on.

And she went to the next trunk. More of the same. She bought almost seventy fur coats, and we were beginning to feel like Cheshire cats, grinning ear to ear.

John came in. "Did we do well?"

I said, "You did great. You didn't buy everything, but you bought plenty."

It was already 10:30 or 11:00 P.M. when we got back to the store. I called Ira, and we all went to sleep that night very, very content.

—Jack Cohen, former fur department buyer

W hen I worked at Bergdorf, one of the executives, Leonard Hankin, had a gorgeous office with a beautiful bar. It was basically a salon, a very chic room, with a low sofa and lots of decanters. Anyone who came in would be offered a cocktail.

I would sometimes get called up there to help when important clients came in. The headmistress of the floor would tell us what to do, and we would run around the store, fetching this or that.

Elizabeth Taylor would come shopping at Bergdorf, and they would take her to Leonard's office. She wouldn't try anything on. She would just sit there and giggle and say, "I'll take that."

One Christmas season, she came in, and I remember exactly what she was wearing, my favorite outfit, a black turtleneck and a zebra print pony skirt. This was around 1972 or '73. She was very *girl*—friendly, bubbly, with a real laughter about her, very joyous. And she ordered black mink earmuffs made by Emeric Partos for a trip to Gstaad, Switzerland— enough to give everyone on her Christmas list a pair.

—**Candy Pratts Price, creative director, Vogue.com**

I have always been of the mind-set that, instead of buying three cheap pairs of shoes, you just pool all that money together and get one great pair, which is why I shopped the shoe salon at Bergdorf. I was there one day in the eighties, and in floats Diana Ross. And she's got on a catsuit and a Blackglama mink coat.

I will never forget how glamorous she was in her catsuit and fur. It was such a simple outfit, but it was genius for shopping, because once you slip off the coat, you can try on anything you like without having to take off your clothes, which makes it less of an ordeal and more of a pleasure. And of course, the mink keeps you warm.

She clearly had her own salesperson. That was a lesson that I took away. You want to try to have a relationship with a salesperson so you won't have to walk around and find every shoe you want by yourself. They will know what you like and whatever is new for the season that you don't already have.

That, to me, is the height of chic shopping.

— **Bevy Smith, social media socialite**

W hen I worked at Bergdorf Goodman as copy chief, Gloria Swanson once came into the store. She was wearing a leopard hat and a leopard coat and she was, almost, like a leopard. She just had a catlike walk, and all the doormen and elevator men—at the time, there were still elevator men at Bergdorf Goodman—they were just aghast.

But Bergdorf has always had those women. They still have those women. Now though, they have personal shoppers or private rooms, and very often, the store goes to them. But Madonna, Mariah Carey, they all shop there. I've seen Beyoncé in the shoe department, trying on some of our shoes and some from the other designers.

— **George Malkemus, chief executive officer, Manolo Blahnik**

Opposite:
A Bergdorf
Goodman
advertisement,
photographed
by Horst, for
Vogue, 1936.

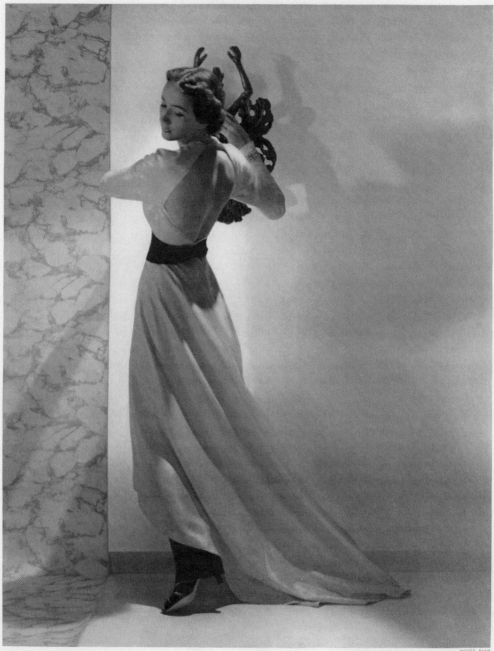

Called the White Peacock. Dedicated to special evenings at home when there's wild duck

or a baritone or a visiting foreigner for dinner. Not intended ever for the outside world.

Done in silver white lame; a cummerbund and under-tunic of crushed black velvet.

One day, they put me in the Oscar de la Renta boutique, to watch over it. I wasn't near that echelon, to be able to sell in there. So I was sitting at the desk and I'm on the phone. And I see this woman with a ski cap on. It was warm outside, so I thought, "Gosh, that's an odd outfit." Then I recognize her as she's rounding the corner—it's Aretha Franklin.

I was raised in Detroit, and when I was growing up, we would go to this Baptist church and we'd sit in the parking lot and listen to the music. And it was Reverend Franklin's church, her father, and that was her singing.

She comes up to me and she says, "Is Oscar here?"

And I said, "No, but I would be glad to get him on the phone for you." So I called the Oscar de la Renta showroom, and said, "I have Aretha Franklin here. She wants to talk to Oscar." They put her right through and she and Oscar had a brief conversation. I don't know what was said. It wasn't my place.

—David Battane, manager, human resources

Emeric Partos was a man from Hungary, and he came to America to be a great fur designer. He originally worked for Maximilian Furs, which had a salon on Fifty-Seventh Street. And it was really where the crème de la crème went to have furs custom made. Somehow he got hooked up with Bergdorf Goodman, which in those years had a workroom on the top floor of the store. So the coats for the clients were custom made, and he was in charge of that workroom.

He was a master of fitting and dying fur in colors that had never been done before. He dyed skins. He would cut up little pieces of fur and he would dye them in his sink. And he was very famous for what was called intarsia. In other words, he would make a mink sweater for a lady and in the middle was a squirrel, but it was actually put into it like a mosaic. The squirrel was in a colorful relief.

He became world famous. He did a lot of furs for movies. He did amazing editorials for *Vogue*, *Harper's Bazaar*. And he was a very small man, temperamental, as most designers are.

For *My Name Is Barbra*, Barbra Streisand's television debut, he made many of her costumes. She arrives

at the beginning in a white horse-drawn carriage, pulls up to Bergdorf on the Plaza side by the fountain, and she gets out and she's wearing this wild Somali leopard fur coat, slit up to her waist. And she keeps changing during her romp through the store. Once she's in white ermine knickers, a white ermine riding jacket, and a top hat like from the circus, made out of white satin.

At the time, she was identified with secondhand clothes, from the song she sang, "Second Hand Rose." So it was ironic that she was in Bergdorf Goodman. And she danced and sang through the halls, wearing fur almost in every scene.

She was quite young in those days, and she was just in the midst of [her Broadway show] *Funny Girl*, taking the day off from the musical to film her television special. The Goodmans had a dinner for her in their apartment on the night it aired.

Barbra was a client of mine for easily ten years. She loved fur. One night, I was in bed sleeping, and the phone rang. My wife answered it, then gave it to me. "Barbra's on the line," she said.

At that time I had a salesgirl named Barbara. I get to the phone and I say, "Why the hell are you calling

me at 10:30 at night? Have you been drinking?"
Because this particular person drank.

So Barbra says, "Who the hell do you think this is,
Jack?" And she tells me. And then she says, "Can you
come up to the apartment? I want to buy some furs."

I told her I couldn't come that night. The store
was closed. "You might think I own Bergdorf
Goodman, but I don't. I don't have the key. I can't
access the vault. I can't shut off the alarm. But I
can get there early tomorrow morning." So the next
morning, I went to her beautiful apartment on the
Upper West Side and she selected some new furs.
— **Jack Cohen, former fur department buyer**

CHANEL

Chanel is composed of only a few elements... camelias, quilted bags and Austrian doorman's jackets, chains, and shoes with black toes. I use these... notes to play with...

-Karl Lagerfeld

Fall 2005 Col...
Tuesday May 10 & ...

One of the quintessential stories of New York City in the nineties is *Six Degrees of Separation*, John Guare's play. And I was asked to do the clothes. It's about someone pretending to be a member of this upper-class WASP clique, breaking into that inner circle and getting to know everyone.

The lady of the house, Ouisa, was played by Stockard Channing. And of course, where would Ouisa have shopped but Bergdorf Goodman? So that's where we went for the clothes.

Stockard is to the manor born, so her choice of clothes and how to accessorize is spot-on. I'd ask her questions and she'd tell me, "Well, maybe I'd wear the nude pumps with that," or "Maybe black is better here because it makes it more afternoon."

When Stockard went off to do her next project, everyone was quite nervous because the next actress to play Ouisa was not, shall we just say, originally from Park Avenue. The playwright himself called me up and said, "William, before I sign off on this, do you think she can play a blue blood?"

I said, "Well, John, she's an actress."

He said, "No, but you have to have that innate sense."

Opposite:
"All Things Chanel,"
store window,
2005.

I said, "John, I'm taking her to Bergdorf Goodman." And that was enough to calm everyone down. She got the job and she was excellent.

When I took her shopping, though, oh my god, was it rough. I think Betty Halbreich at Bergdorf, who always helped me, really earned her stripes that day.

— **William Ivey Long, costume designer**

I went to high school in the fifties. In our senior year, we were given jobs: one week we would work, and the next we would go to school. My assignment was to work at Bergdorf Goodman.

After I graduated, the buyer for the stationery department approached me and said, "I'd like you to work in my department. I would like to train you." I was a little over eighteen when I started working full time.

The stationery department was located at the Fifty-Eighth Street door, on the right side of the rotunda. We handled Christmas cards for celebrities, wedding invitations, birth announcements, engagement announcements, at-home cards—"Mr. and Mrs. Jones will be at home at a certain date," or "We have taken up residence at . . ." We did stationery for people's country homes. We engraved personal items, canasta cards, anything that involved printing.

A couple of times, Cary Grant came in. He would be looking about, not really buying anything. Tony Randall came in several times, and he did purchase stationery. Peter Lawford bought a little something for his fiancée. He was engaged, at the time, to one of the Kennedy sisters.

One day, we were all at the counter discussing a new paper that had just come in. We looked up, and there she was: Grace Kelly. She was all alone. I don't know if she had anybody waiting for her outside, but we didn't see any secretary or family or friends.

We all knew about her engagement to Prince Rainier, of course. It was in all the papers and the wedding date was set. We were just amazed because we didn't know she was coming. We thought if she was considering Bergdorf, someone would have notified us prior. But she just walked right in, like anyone off the street.

She was absolutely beautiful.

We all greeted her naturally. "Miss Kelly, good afternoon. Please sit down. It's a pleasure to have you here." My boss shook hands with her. She said she was interested in wedding invitations. We showed her all the different books. We all chimed in from time to time, assisting her with her questions, explaining about the options, comparing one invitation to another, things like that.

She ordered the invitations that very day—my boss was extremely pleased with that. I think she was leaving town, so any adjustments were handled by mail or phone, but she had mostly picked everything

out at that point. We had her at the counter for, I would say, a good two hours, and she was as charming as charming could be.

— **Marion DeMartini, former employee**

When Jacqueline Kennedy was preparing for her husband's inauguration, she had just had a baby. In a typical husband-and-wife scenario, the president-elect assumed his wife was very busy with the children, so he thought he would expedite who would design her inaugural gown.

He asked his good pal Oleg Cassini if Oleg could come up with some ideas. But unbeknownst to President Kennedy, Mrs. Kennedy had already conferred with Ethel Frankau, the fashion director at Bergdorf. And together, they, along with the legendary fashion editor Diana Vreeland, had come up with a beautiful design.

So Mrs. Kennedy was in a little bit of a bind. She didn't want to put her husband in an embarrassing situation, of course, but she also knew that she had a commitment with Bergdorf Goodman.

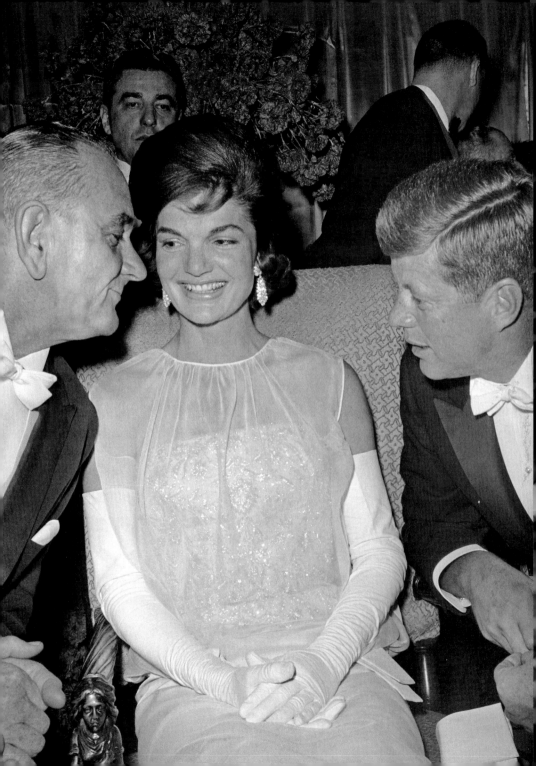

It was a very delicate situation, and she knew that Ethel Frankau would not be happy if she backed out of their arrangement.

So there were many machinations and in the end, she very diplomatically decided that Oleg Cassini would do the coat and dress she wore to the actual inauguration—wool melton with a fur trim collar— and Bergdorf Goodman would indeed do the most important dress that she would probably ever wear for the Inaugural Ball.

It was a beautiful white satin dress with a purity to it, very simple, with a white coat. The lines were perfect, and of course, it became one of the most famous garments in the world.

I learned all of this from Ethel Frankau's great-niece, Edla Cusick, who is a good friend, and who has all the letters from Mrs. Kennedy to Ms. Frankau. They were very charming, and they told the whole history of how it happened, down to the detail of President Kennedy coming into her hospital room after she had given birth to John Jr., saying basically, "I've just taken care of something for you," and she thought, "Oh, dear. You didn't really take of it. Now I have a fire to put out."

You could just tell from the letters she was inspired by and in awe of Ethel Frankau. She listened to her and also to Diana Vreeland, who was a great mentor as well. She recognized that as first lady, she had a very important role, and she took it very seriously and depended on Bergdorf Goodman to help her establish her image.

— **Wendy Goodman, design editor,**
New York Magazine

Mrs. Kennedy—well, she was Mrs. Onassis by then—would walk down Fifth Avenue from her apartment to come here. She would wear an old, beat-up raincoat so that no one would recognize her on the street. But she still couldn't eat at the restaurant. We'd have to serve her in the fitting room, so she wouldn't be bothered. And we would all be thinking, "Why would anybody want to be her?" What kind of a life was that? But she was so nice and she shopped a lot here.

— **Dawn Mello, former president**

Page 126: Sketches by Larson of Jacqueline Kennedy's Inaugural Ball gown designed by Bergdorf Goodman fashion director Ethel Frankau. Page 127: Lyndon B. Johnson with President and Mrs. Kennedy at the ball, January 1961.

There was another story where Jackie O. left the store one day with a package that she bought, and there was a security tag left on the dress. She went to the door. The alarm went off. Luckily, Pat Salvaggione, the famous Bergdorf doorman, was there and he took care of it. He told her, "If we don't take it off, it'll keep opening garage doors on your way home."

She appreciated his sense of humor, and was very appreciative of people who took care of her.

— **Ira Neimark, former chief executive officer**

Jacqueline Kennedy Onassis came in not long after I started, and they asked me to show her something. I was so frightened and so nervous and so really new that I got off at the wrong floor. I walked her out of the elevator, and she spoke very softly, in a whisper, "Oh, dear. This is not the second floor." I was so embarrassed. You know these very famous people, it can be almost scary to help them.

— **Carole Wasserman, sales associate**

Opposite: "Comparative Philosophy: Karl Lagerfeld versus Coco Chanel," store window, 2005.

I was asked to do a scene in *The Muppets Take Manhattan*. We filmed it in Bergdorf. They opened up the store on a Sunday, and I was with Miss Piggy. In the movie, we were working there. I was a little upset, though, because that swine stole the show from me.

Under the counter, Jim Henson was working Miss Piggy with the hand and all that, and she was so life-like and so funny that in between takes, I would still talk to her. You know how stupid that is? I would say, "Oh, that was good, you want to try it again?" And then I realized, "I'm talking to a rubber pig head."

But it was great. And then we got fired from Bergdorf at the end of the scene. And rightfully so, because we were throwing powder on each other.

The other thing that hurt was, I had one costume. Miss Piggy had three. So they would change her in between takes. But I had to pat myself down a lot to get all the powder off. But it was so much fun working at Bergdorf.

I haven't had the pleasure of working with Miss Piggy again. But I think she's looking amazing. She looks exactly the same! I want to find out who her surgeon is.

—**Joan Rivers, comedian**

When I first started working at Bergdorf, two women came in together in very masculine clothes. It was winter, and we had a little boutique inside the fur salon, and they disappeared into where we kept the men's furs.

I watched for a second, and this woman kept trying on the men's coats, but she was clearly a woman, in pants and an overcoat and a slouchy hat.

I walked up to her and said, "Can I help you?"

And she said, "Yes, I want this coat. What do you think? Does it fit me?"

I looked very carefully at her. She was quite wrinkled. I'm usually very good at spotting celebrities—I can spot them a mile away—but she did not look familiar.

After she bought the coat and left, one of my cohorts came up and said, "Do you know who that was? Do you know who just bought a coat from you?"

And I said, "I have no clue."

"That was Greta Garbo."

—Jack Cohen, former fur department buyer

I've seen them all: Patrick Swayze, John Travolta, Brad Pitt came in with Gwyneth Paltrow when they were dating. Another day, I was standing in the men's department. They had a big table and I was leaning on it, resting my elbows, with my chin on my hands, which you are really not supposed to do. And this, what's his name? The famous singer from New Jersey, Bruce Springsteen, suddenly appears and he puts his elbows down on the table and looks into my eyes and goes, "Could you please tell me where to go to find socks." Or something like that. I got a big kick out of him.

When John F. Kennedy Jr.—John-John—was young, he would come into the store wearing roller skates with his backpack on. He must have been in high school. And he would just roll through, looking at everything, taking it all in.

—Carole Wasserman, sales associate

I've worked on a lot of films and television shows through the years, since I started at Bergdorf: *Arthur*; *Annie Hall*; *Eat, Pray, Love*; *Little Fockers*; *Sex and the City*; *30 Rock*; *Gossip Girl*; *Black Swan*.

I did some of the earlier films for Woody Allen, including *Manhattan*. I remember doing Mia Farrow for one film. We were putting her in a little dress that was $125 at the time. While I was dressing her in the fitting room, she said to me, "Do you know how many meals this would buy for the children in Biafra?"

Raging Bull, that was a very difficult movie to make, but I only know from dressing the women. A very creative costume designer who's since passed away, John Boxer, did that movie. It was so much fun working with him. In those days, we could run around the store, day and night, and we could go into stockrooms. We picked through boxes and he'd find pieces of clothing that you'd never think he'd use.

That's when he put a snood back out there—it is a crocheted piece, almost a bag, that you attach to the back of your head, but you have to have a lot of hair to stick into it. It became such a sensation after Cathy Moriarty wore one in *Raging Bull*.

BERGDORF GOODMAN

AKRIS

View the Spring 2011 Collection
Tuesday, January 18-Thursday 20
Fourth Floor 212 872 8849

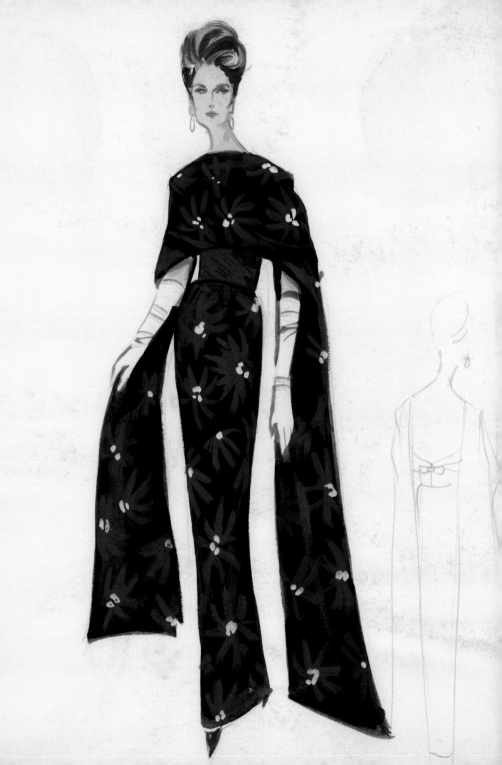

People hadn't seen a snood since the thirties and forties.

Patricia Field is another incredible costume designer. I started with her way back with the first *Sex and the City*. Pat doesn't say anything. She picks. If you ever see us work together, we walk the floor and she'll glean out something and just keep layering, until it's about to burst. But it works. Her costumes are over the top, but that is what she's known for.

Katharine Hepburn used to sit outside my fitting room in her later years. She was a beautiful woman. Audrey Hepburn came in too. I taught Candice Bergen to walk in high heels right here. She came in to see me with Ali MacGraw once. They were friends; they shopped together. Christie Brinkley came in and wanted me to find her a dress to wear to the Academy Awards.

In those days, everybody was walking around with a cigarette, if you can believe it. They had canister ashtrays for cigarettes around the store. When I go back and think about it, it's almost impossible to believe. But we all smoked—can you imagine what the clothes must have smelled like? And what about the damages? The burn marks? Who knows?

Probably the only person I was ever in awe of was President Ford. He was as good as it gets. They called ahead. They had an emergency. They were going to a huge party and Mrs. Ford needed a dress for that evening. Little did I realize, the president was coming as well.

He sat right over there in that chair. She was in the dressing room. I would go back and forth. She would come out and parade the dresses in front of him. They were so crazy about each other. They could've been any couple from anywhere in the United States. You never in your life would have dreamed this man held the office he did. And she was lovely. Really tiny, kind of frail, pretty. They sat here while I got the dress altered. Then she left, but he waited for the dress, with Secret Service men outside.

The dress comes down. He picks it up, and I said, "You can't carry it that way."

He turns to the Secret Service men and says, "Look at her. She's going to teach me something."

He threw it over his arm, and I said, "If you crush this, I won't be there to press it again." I heard from them when they moved out to California. We corresponded.

— **Betty Halbreich, personal shopper**

Page 136: Bergdorf Goodman's advertisement for Akris, the *New York Times*, spring 2011. Page 137: Balmain gown, spring 1963, original sketch rendered by Bergdorf Goodman.

Mrs. Brooke Astor was really quite elderly and still coming in. I'd see her on the third floor and she would be looking at the clothes from all the young designers. She wanted to know what was going on, so she would be looking at Marc Jacobs. I couldn't believe it. I mean she was never going to buy any of it. Could you see Mrs. Astor in the latest from Marc Jacobs? But she still wanted to stay current, even then.

— **Dawn Mello, former president**

The last customer that dressed to come to the store was Brooke Astor. I met her when I was still selling here. I had read in the newspaper that she'd fallen and she'd hurt her hip. She came in with a cane, but still fully dressed with the gloves, the hat, and the whole thing, and said, "Excuse me, but is Serge here?" Serge was her salesman.

I said, "Mrs. Astor, if you would like to wait here, I can go and find him." So she sat down and I went to find Serge. He was just finishing up with a customer, so I went back and sat in the chair next to

her to keep her company until Serge arrived. "How are you feeling?" I asked. "I've heard you weren't well . . . ?"

"Oh, I'm much better," she said. She was very open and communicative.

In the next shop over, a woman was having her dress shortened. A fitter was on her knees, pinning the skirt, and I see the customer look over, and she spots Brooke Astor. This woman dashes over — I mean *dashes* — leaving the fitter on her knees holding the pins — and she grabs Mrs. Astor's hand.

"Mrs. Astor, it's so nice to see you," she says.

Mrs. Astor was a little taken aback. She said, "I'm fine."

The woman then understood what she had done and quietly went back to her fitting. Then Mrs. Astor turned to me and said, "Who is that woman, and how does she know my name?"

That, apparently, was just classic Brooke Astor. Because everyone knew who she was. She knew how famous she had become, and she really dressed for the people. She knew her role. So she was making a joke. But I didn't get it at the time.

— **David Battane, manager, human resources**

I happen to live three blocks from Bergdorf, so I pass through the store all the time. One day, a personal shopper stopped me and said, "Roberto, please, I need your help. Get earrings and a lot of bracelets for a tall beautiful blonde."

So I go to our jewelry counter and bring some things upstairs. I open the door of this room, and I see this gorgeous half-naked woman. It was Katherine Heigl. I was so stunned I just blurted out, "Wow, you're beautiful." I couldn't think of anything else to say.

She was pretty funny. She looked me over and said, "Yeah, well, you're hot too," which made me laugh.

Amedeo Scognamiglio, my partner, and I like to say we play Barbie with our clients. We like to play dress up. So Katherine and I played dress up together, and I put her in all sorts of things. And the next week, I turned on *David Letterman* and there she was, wearing our cuffs and earrings.

—**Roberto Faraone Mennella, jewelry designer**

A few years ago, we kept getting this strange request for the "Oprah earrings." And we didn't know what people were talking about. We thought maybe it had something to do with an oval shape, something that looked like the letter *O*. But it started to be very strange, because in every city in America we visited, somebody would ask us for the Oprah earrings.

Finally, we said, "What is going on here?"

And someone told us, "I think Oprah wears a pair of your earrings all the time on her show."

But we didn't know for sure. We had never met her, and she had never called our showroom, our publicist, anything. So we were just embarrassed, more than anything. When people asked if those were our earrings, we wouldn't say yes, we wouldn't say no.

Eventually, someone sent us to her website, to watch her most recent show. Much to our surprise and happiness, she was really wearing our trademark earrings, in silver. But we still had no idea where she had gotten them. So we asked one of our friends at Bergdorf, one of the personal shoppers. And she said, "Oh, of course those are yours. Oprah's been buying your jewelry for years."

— Amedeo Scognamiglio, jewelry designer

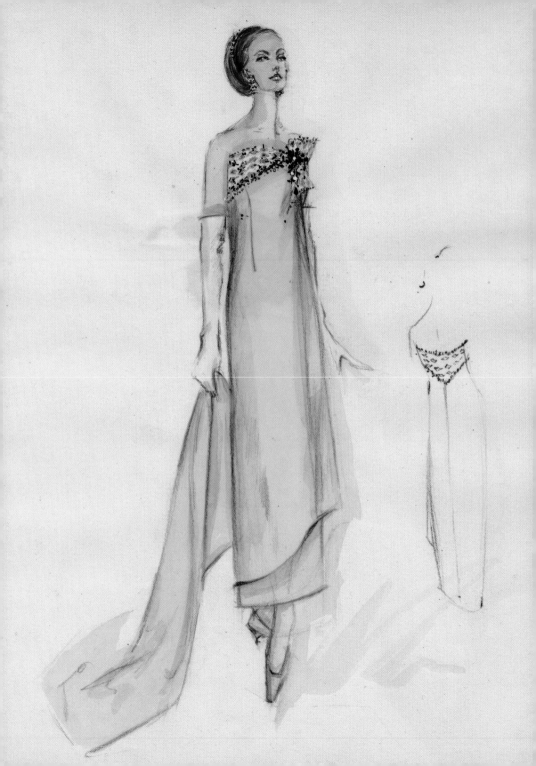

BERGDORF GOODMAN

DYNAMIC *since 1901*

LANVIN

View the Spring Collection
Fourth Floor 212 753 7300

S ome of the celebrities are just a little too . . . overprivileged when they come in here to shop. I've had them take clothes off and kick them across the floor, then wait for me to pick them up.

I can't name names, but there was a diva here once, a true diva. She was a singer and an actress— young, gorgeous, very famous. And she wanted everybody in the store to know who she was and that her presence was here.

She requested in advance that I have some peignoirs and lingerie in the dressing room for her to wear in between changing clothes. The little number she chose to put on was very flimsy. And all of a sudden, she decides she needs to see something on the third floor. I said, "Well, I'll wait. I'll wait for you to get dressed."

And she said, "No, no. I want to go now." And so off we went, with her in her little negligee and high heels, parading around the store for everyone to see."

—**Elaine Mack, personal shopper**

W hen I was first asked to be in Bergdorf, I told them, "It's my dream to be here, but I want to have a trunk show." Now, I didn't really know what a trunk show was at the time. I just remember reading Bill Blass did all these trunk shows, and Oscar [de la Renta] did trunk shows. So I had to have a trunk show too.

Women were just casually throwing the clothes all along the floor. We had thousands and thousands of dollars' worth of samples, and we'd sit there and I'd say, "No, let's get the tank top," or "I'd go with the turtleneck."

At the time, it seemed to be a trend that women would wear pantyhose without any panties. I was kind of shocked that they would come out of the fitting room bare-bottomed. You know, now I realize maybe they thought I was a rock star and this was all acceptable.

New York women, especially Bergdorf women, are very forthcoming. They tell you everything. Sometimes too much.

— **Michael Kors, designer**

Page 144: Lanvin gown, 1966, original sketch rendered by Bergdorf Goodman. Page 145: Bergdorf Goodman's advertisement for Lanvin, the *New York Times*, spring 2011.

W hen my *So80s* book came out, Bergdorf wanted to throw a party. But I said, "It's got to be a big party. Like a party from the eighties. And I want it on the main floor." Which they never do, but they made an exception for me. People were dancing. A couple of people were smoking things they shouldn't have been smoking. And I do remember, there were two people actually . . . making love, for want of a better word, behind the counters.

Somebody said, "This is a first. Even for us."

I consider that party a success.

— Patrick McMullan, photographer

O ne of our most exciting events was for a gentleman client from Phoenix who wanted to throw a very special fiftieth birthday party for his wife — and this was her favorite store. So they flew in just for the day. It was a total surprise. We had a dinner party for the family set up here at the restaurant, for about twenty people, so we prepared one long table. We wanted to keep it cozy,

so we brought in some trees and things to make it seem like they weren't in a big empty room.

After the dinner, which was wonderful, the husband said, "Darling, happy fiftieth birthday. The store is yours tonight." We had arranged for the store to be open just for her. Of course, she and the daughters went crazy. Furs, jewelry, anything they wanted, they could have. And for the gentlemen, we set up a cigar and cognac lounge.

Throughout the evening, we were serving little nibbles and champagne. They could go anywhere they wanted within the store—which took a little anticipating and arranging, to prepare for whatever they wanted to do next. But we also had a little salon set up for them in Personal Shopping so they had someplace to go back to and regroup.

That was the probably the most extravagant event we ever handled.

— Michael Perricone, director, BG Restaurants

For many years, *All My Children* was shot here in New York—basically, my whole adult life. Betty Halbreich of Bergdorf Goodman began to work with us very early on. Our costume designer was a friend of hers, and they would pull some of the most beautiful clothes in the store, and therefore on the planet, for Erica Kane, the character I played.

I'm sure the producers provided a budget that allowed for Erica to be dressed from Bergdorf. I just always felt so lucky that I was the actress who got to play her and that I could go to work every day and wear all these gorgeous clothes.

Later, I would come in, and I would run into Betty because she's so hands-on and all over that store. Betty just knew what was right for me. I've found her to be honest, but that's what I like. I don't want a yes-man around me all the time. You can't learn anything that way.

— **Susan Lucci, actress**

Opposite:
"Gothic
Splendor,"
store window,
2006.

One day, a bag lady came into the fur department. She kept looking at this particular fur, which was displayed in the center of the salon. The coat was a Russian sable—extremely expensive by today's standards, probably a quarter-million dollars for the time. She kept touching the coat—and wanting to touch it.

My grandfather [Andrew Goodman] said politely to her, "Excuse me, ma'am, can I help you?" You know, he was trying to kind of usher her out, but not forcibly, just talking with her.

She said, "I really love this fur. I really want to buy it."

And he said, "Well, that . . . that would be nice."

She said, "How much is it?"

He said, "Well, it's very expensive."

And she put one bag down and she started pulling cash out of another and bought that sable coat.

Who was she? I don't know. My grandfather said that that was the day he realized how important it was to always be nice, to always be courteous, because you never know what sort of bag might be full of money.

— Andrew Malloy, grandson of Andrew Goodman

During my time at the men's store, one of the best customers we had was a Middle Eastern prince who would come to town a few times a year, at the beginning of the season. And he had his salesperson that he trusted and liked, and she would pull together pretty much half the store and would go to his hotel.

It was fun for me because she would pull me in and say, "Okay, what's new, what's great, help me put some looks together and really personalize it for him." We knew his size, we knew what he liked, we knew what he bought last season, so we could help him build on that.

There were a lot of guys who were like that—celebrities, politicians, men in the financial world. It would be nothing for a guy to come in and drop $100,000 to just take care of everything all at once. That's kind of the beauty of how men shop. They're extremely loyal once they find a place that makes them happy.

— **Michael Bastian, designer**

I became very friendly with a lady from Houston. Her husband was a well-known doctor down there. She would come to New York every few months and she would buy fur like you never saw in your life. She was a very large woman, so she bought a lot of capes and ponchos and very big coats. And she would purchase the coats, but she would never allow us to ship them to Houston. We had to keep them here in storage in the basement. She didn't want her husband to know that she was spending this extraordinary amount of money.

Every month or two, she would fly up to New York, notifying me in advance that she was coming. And I had to bring all her furs out of storage. There must have been seven racks full of the most amazing pieces you ever saw. She would just stand there in front of the mirror, trying them all on, visiting. To this day, I believe that they're all still downstairs in a vault.

—Jack Cohen, former fur department buyer

There was a story in my family that when World War II broke out, my mother went to Bergdorf and just charged and charged and charged because she figured New York would be bombed and it would wipe out the billing department. And then nothing happened to New York—thank god.

But my father said my mother would run and stand in front of Bergdorf at night, holding big spotlights, hoping enemy planes would fly over.

—Joan Rivers, comedian

DESIGNERS
ON DISPLAY

"I think it's every designer's dream to land at Bergdorf at some point. It's Shangri-La."

—Rachel Zoe, stylist and designer

Some of the most prolific and influential designers of the twentieth century got their start at Bergdorf Goodman. Halston ran the millinery department before the store launched his first dress label. Dawn Mello, former president, discovered Azzedine Alaïa and Michael Kors, among others, and encouraged Donna Karan to venture out on her own. "A couple of us had to practically drag her away from Anne Klein," Mello recalls. "We kept telling her, 'You can do this yourself.' She cried. She didn't want to. She was afraid to go it alone. But to her credit, she found the courage and she did it. And Bergdorf Goodman was her first order."

Whether through over-the-top fashion shows or intricate window displays to showcase their designs, Bergdorf Goodman gets behind its designers. "For many years, the store had been living on the reputation of a fine old New York establishment, but we were missing the hot designers who had gotten into Bloomingdale's and Saks," former chief executive officer Ira Neimark says. "When we finally got them, we promised them the world: fashion shows, Fifth Avenue windows, major advertising. We did things

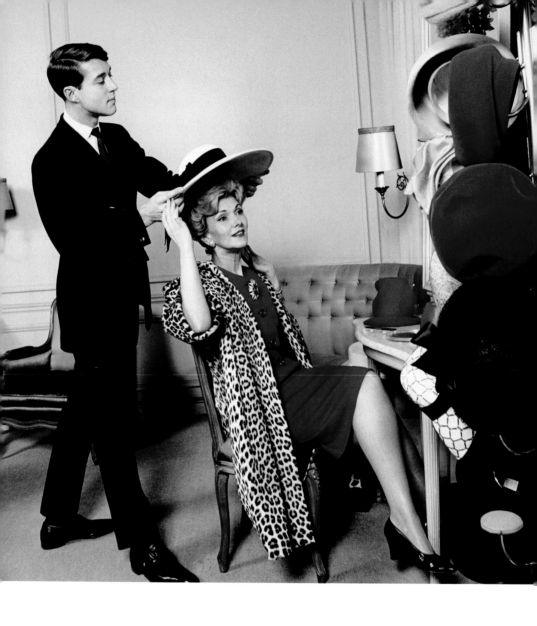

for them that none of the competition had done or would ever do. We overpromoted them, and eventually, the designers said, 'We're more important than the retailers.' And they went out and developed their own stores."

Now there are designer flagships up and down Madison and Fifth Avenues that compete daily for Bergdorf customers. The designers' own websites stream their shows live on the Internet, and a few even take direct orders a season ahead.

Which doesn't mean there aren't kids fresh out of FIT or Parsons, lining up to meet with the Bergdorf Goodman buying team. "It's such a milestone, being included there, for a young designer," Thakoon Panichgul says. "On top of the recognition, there's an excitement here that makes people want to shop."

And when a single store can make—or break—your career, you tend to remember the moment its team first came calling.

Opposite:
Halston fitting
a model at
Bergdorf
Goodman, 1962.

I would say Halston was one of the great designers of the twentieth century. He ended up creating a style of minimalist dress that is different than what most of us call minimal. It was minimal, but it wasn't simple. It was so beautifully rendered in terms of its technique. His pattern pieces were like supple origami. He began, of course, as a milliner, and he became known at Bergdorf Goodman. Most milliners who become dress designers, like Charles James, make dresses that can stand up by themselves. Halston took these very simple sculptural shapes and transformed the way a woman's face looked. He was brilliant.

—**Harold Koda, curator-in-charge,
the Costume Institute at the
Metropolitan Museum of Art**

This is where Halston landed after being out west in Chicago and making his first hats. He came to Bergdorf and had a little boutique corner here. They nourished his talent. They saw to it that he dressed the most elegant women in New York. I think he made a lot of good connections here—Jacqueline Kennedy, Grace Kelly, Audrey Hepburn. All those ladies met him here first.

He always talked about Jackie O. being one of his favorite people. But it was tragic, wasn't it? She wore a Halston pillbox the day Kennedy was inaugurated and the day he was assassinated. So that hat has had its good times and its bad.

— Pat Cleveland, former model

I remember Andrew Goodman and his wife, Nena, told me a story about going to the Hemingway Bar at the Ritz hotel in Paris one evening. They saw Halston coming in with a friend, and he was drinking champagne and eating caviar, and Andrew was a little disturbed. He said, "Here we are paying for his whole damn trip, and Halston is really living it up."

But he did such amazing things for the store, creating the pillbox hat which Jackie Kennedy made famous. So he deserved to be treated well. And overall, Andrew was happy. It was a great relationship.

—Ira Neimark, former chief executive officer

My first connection with Bergdorf was when I came to this country at the age of twenty to work for Halston. I was supposed to be coming here to go to school, but Halston asked me instead if I would be the liaison between my family's factories in India and his embroidery production. His connection with Bergdorf was so strong that I began to feel it too. Our offices were on Fifth Avenue, and we would all walk down to see the windows at Bergdorf. And later, my first collection went to Bergdorf.

I basically learned everything from Halston. We worked with Liza Minnelli, Elizabeth Taylor, Edith Head; we went to Studio 54 with Bianca Jagger.

Andy Warhol taught me how to draw. I was sitting at my desk, drawing Warhol's poppies, which Halston had given me as a pattern for a dress for Betty Ford. Little did I know that Andy was standing behind me, watching me. He put his hand on my shoulder, and he said, "Naeem, let me show you how it should be done." He taught me how to hold my pencil. He was basically saying, "Don't be so hard on your hand. Just let it flow."

—**Naeem Khan, designer**

BERGDORF GOODMAN

DIVINE *since 1901*

**OSCAR
DE LA RENTA**

View the Spring Collection
Fourth Floor 212 872 2656

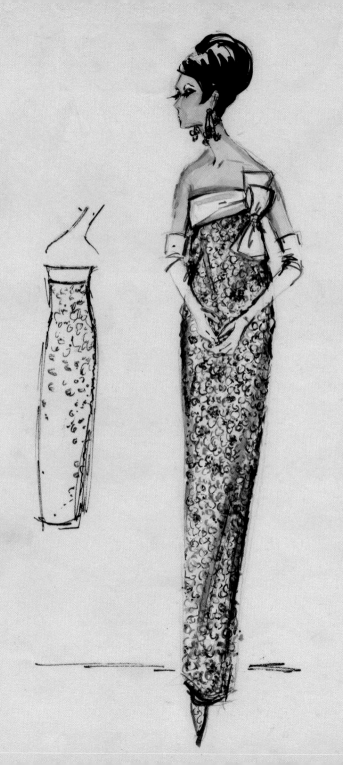

When I first heard Bergdorf Goodman was going to come to see the collection, I was just worried about one thing: I had no collection. I had only summer, and they were coming to visit for winter. So I thought, "What can I show that would look like a winter shoe?"

They came in March '92. I had one store in Paris, and that was the only place to find my shoes. I wasn't in any other stores.

A regiment of people arrived. I was not expecting so many people to come see one new line. And so they came and they said, "Where is the winter collection?"

I said, "Well, actually, this is all I have."

They said, "This is perfect."

I said, "But this is the old collection."

They said, "We don't care. Nobody knows you at this point"—this was first time I would be brought to America—"it doesn't really matter as long we love the shoes, that is what counts."

So I thought, "Well, they're right." They made it very easy. I just had started my company. I really had no idea how it all worked. They were very comprehensive and very nice about dealing with

a young designer who didn't know even what the prices should be.

I remember exactly the order. It was 330 pairs of shoes.

— **Christian Louboutin, designer**

A t Bergdorf we did once have a bride who asked us to make her dress waterproof because she wanted to swim in it. "You want to do what in it?" I didn't make it waterproof. I was a little worried she might drown.

— **Georgina Chapman, designer, Marchesa**

Page 166: Bergdorf Goodman's advertisement for Oscar de la Renta, the *New York Times*, spring 2010.
Page 167: Lanvin gown, spring 1967, original sketch rendered by Bergdorf Goodman.

When we were first starting out, we sent paper dolls to a bunch of people in New York. And we actually didn't hear from anyone. We got a hotel room for two days because we could only afford two days. Before then, we couldn't ever invite any buyers, because we would stay at our friend's house, which had, like, twelve cats in it.

Finally, Roopal Patel, who was the women's fashion director for Bergdorf, agreed to come over to our hotel. So she was our first buying appointment. At that point, we only had ten pieces. We couldn't really put the collection in a department store because it was too small and would get lost. But the next season, we worked with Roopal and we had an amazing first time at the store with that collection.

—Laura Mulleavy, designer, Rodarte

I n 1979, my parents gave me a trip to New York. I took in all these key impressions that week, and Bergdorf Goodman was definitely one thing I kept in my mind. I wanted to have my collection represented there, and I took that idea home as a wish, a dream.

In 1984, I started writing to Dawn Mello, saying I would like to meet her. And then in 1988, this remarkable thing happened. She just arrived in our showroom. She said, "Albert, I'm finally here. You've been writing to me and calling me and I've heard a lot about your collection. I want to have a look at it."

This was really a dream come true. You know, I still think it's every designer's dream to be in the windows of the world: that is what Bergdorf Goodman is for me.

—Albert Kriemler, designer, Akris

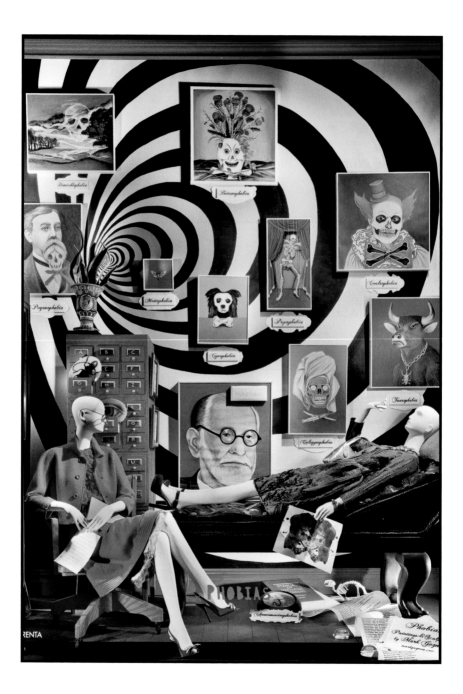

The first time I met Michael Kors, I was just walking across Fifty-Seventh Street, and I looked in the windows at a store called Lothar's. I saw a mannequin and a wonderful young man standing up on a ladder. So I knocked on the window, and he came down. I think I said, "Would you please tell me the name of the designer of these clothes?"

He said, "I did them." I asked him who the manager was. "I'm the manager. I'm selling," he said.

"So you designed the clothes, you're dressing the windows, you're selling, and you're running the store?" I asked. "What else can you show me?"

He brought his line in to Bergdorf. It was all sportswear, but it had an elegance to it, a refinement that one did not see in sportswear at that time. Once we carried him in the store, he showed up every day to sell in his little boutique. It was only about the size of four card tables, but he was there to wait on the customers. And that wasn't very common at the time. But it is really why he was so successful. Joan Rivers and these other really well-known personalities would buy from him, and that was part of what got his name out there.

— **Dawn Mello, former president**

Opposite:
"The Psychiatrist,"
store window,
2011.

I didn't set out to work at Lothar's. I applied to Bergdorf first, while I was still in school, to be a salesperson. But I was told that there was no part-time student sales help. So I was dejected because Bergdorf was really where I wanted to be.

I went right across the street to Lothar's, a store that used to be at Fifty-Seventh Street and Fifth Avenue, and I think I actually was just shopping. But I ended up getting a job there. Then I started designing for them and doing the windows and doing the advertising and doing everything.

My clothes must have looked quite different than the tie-dyed, Saint-Tropez-type Lothar clothes that had been there before. When Dawn [Mello] came in, I saw this very chic woman. I'm a lover of beige, and I think we were both in head-to-toe beige. I could tell she was someone who understood beautiful fabric and neutral colors.

I did not know what her title was. I later found out that she truly was this explorer, finding new things and really changing the direction at Bergdorf Goodman. Dawn and her team, they were blowing the cobwebs off of the building in a big way.

Quite honestly, when she asked to see my line, I had no line. The minute she left, I thought, "I've got to get a line!" I put together a fall collection. It was all brown and black, but very luxurious. I made all the clothes. I had people sewing at my apartment. My mom dropped me off at Bergdorf, and I brought one model with me, and I think I made Dawn and her team sit through what had to have been a very long fashion show with one model changing in between each look.

By the fourth outfit they asked me to excuse myself, and I had no idea what that meant. Then they called me back in and said, "Thank you."

And I was like, "Don't you need to see the rest?!" I didn't know then that people could form an opinion without sitting through a whole presentation.
— **Michael Kors, designer**

I actually started my career at Bergdorf Goodman. I was hired as the copy chief of the advertising department. I was twenty-two years old, so it sounded like a very grand job at the most elegant store in the world. But then I found out that there was only one person in the copy department. So basically copy chief was just a very nice title.

One Monday morning, Dawn Mello said to me, "Hey, George, I want to see you in my office after lunch."

And I thought, "This is it. I'm going to be fired." I went to see Ms. Mello. She kept me waiting for twenty minutes. When her assistant called me into her inner sanctum, which was beautifully decorated, I sat down, and Ms. Mello said, "George, you've got a thing for ladies' shoes."

And I thought, "Wow. I don't know what that means. Is that some kind of comment on my personality?" But I said, "Yeah. I kind of like ladies' shoes."

She said, "You really should go across to Sixty-Fifth and Madison and meet this designer who's opened a boutique. His name is Manolo Blahnik, and he is struggling in New York. He just hasn't really found his client. I think he's looking for a partner.

I would hate for you to leave Bergdorf Goodman, but you would be great at this."

So I walked across to Madison Avenue and was mesmerized by these fantastic shoes. The shop was this little jewel of a boutique, but it was not doing well. So I decided with my partner, Anthony Yurgaitis, to fly to London and to meet Manolo—and the rest is history. We bought the company's US presence, and then we started getting his name going and meeting all the designers. Having been at Bergdorf, I had met Calvin Klein, Perry Ellis, Oscar de la Renta, and Bill Blass—a lot of the important American designers. So I had a little cachet. I would go in to these designers and say, "Remember me? I used to work at Bergdorf Goodman. And now I've bought this company called Manolo Blahnik. Could we design shoes to go with your clothes?"

That's how we started with Manolo Blahnik in America. We made shoes to go with every designer on Seventh Avenue.

**—George Malkemus, chief executive officer,
Manolo Blahnik**

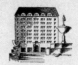

BERGDORF
GOODMAN

Bergdorf Goodman

Designer Original

from the Spring Made-to-order Collection

Great chic, great charm

embodied in this evening beauty

of rich black rayon crepe

with wreath-shirred black silk chiffon

for its yoke and baby-barrel sleeves,

and romantic pink roses, three hither and one yon, for sweetening.

ON THE PLAZA • NEW YORK 19

BERGDORF
GOODMAN

5TH AVENUE AT 58TH STREET

That we ended up in America was due to Bergdorf. In 2005, we came in for eight weeks to do a collection for them. We never left!

—**Keren Craig, designer, Marchesa**

I met a very nice lady named Alison Rose at a cocktail party. I asked her what she did for a living and she told me she was a cosmetics buyer at Bergdorf. And I said, "Wow, guess what . . ." She knew I was a makeup artist—I had this lipstick that I'd been selling by mail order. I said, "I'm looking for a store." I told her the premise of Bobbi Brown Essentials. And she said, "That's a great idea." So she went to a meeting and she called me up a couple days later and said, "We'll take it." That was twenty-one years ago.

—**Bobbi Brown, founder, Bobbi Brown Cosmetics**

Opposite:
An advertisement
for Bergdorf
Goodman, *Vogue*,
March 1945.

Bergdorf has been really important for us. When buyers come to see the line, a lot of places will say, "Oh, that's too expensive. Can you do it at a better price point?" or "Can you do it with a little less of this or that so that it's easier for our customers to wear?"

But Bergdorf's attitude is: bring it on. Crepe embellishment, more sequins—they kind of just go for it. As a designer, it allows you to be at your utmost creatively.

— Stacey Bendet Eisner, designer, Alice + Olivia

In fall 1998, my bags had just been picked up by Bergdorf. I was more than happy to sell here, but I didn't ask where they were going to put my things. I came to the store to see them, and my bags were on the main floor with my name written on a plaque and everything.

I immediately thought, "Who is going to buy these?" I got scared no one would, so I bought two. I paid full retail price for two of my own bags.

That day, someone from the store called me and said, "We just sold two bags!" I was horrified, because that was me. But then they sold two more, and in all, I think they sold nine on that first day. But I was the first to buy two.

It was just a small collection, with eight styles, in five colors.

— Nancy Gonzalez, handbag designer

When I first started out, I don't know why really, but it was a given I would be in Bergdorf Goodman. Before I even started my line, before I had my first show or anything, I was making clothes, and Dawn Mello came down and saw the clothes, and she picked out some things, and the next thing I knew, my clothes were in Bergdorf.

Shortly after I shipped the first collection, there was just one coat left. Bergdorf called and they said, "Liza Minnelli was just in. When she was on the escalator, she saw your coat, pointed to it, and said, 'I want that.'" So they told me they were sending her down to my studio.

We had no time to prepare, so whatever tidying up we could do, we did. And in came Liza with a few people from Bergdorf Goodman. And they ordered all these clothes. It was so fabulous! She had been a big idol of mine—obviously, right?—for years and years. So it was this big thrill. And it had the double thrill of being Liza and Bergdorf.

I don't know for sure, because I'm not a parent, but parents have this intense stress about their children making it into certain colleges. And now it

starts with, like, kindergarten, and you see all these nutty people going crazy, trying to get their kids into good schools. That's sort of what Bergdorf is like. If your clothes are not at that store, then they have no future.

Throughout my whole career, Bergdorf never left me for dead. Where other retailers, yes, they have left me for dead. Bergdorf has never done that.

—**Isaac Mizrahi, designer**

I remember Dawn Mello coming down to our showroom. I would like to think it was more garmento, but it was really just ghetto. I'm sure we'd invited her many times, but she'd never accepted. And then all of a sudden, she heard about the collection from someone and wanted to come up and see it for herself.

She was going through piece by piece, and looking at inside and out, and lifting up the sleeves. I'm thinking, "Oh my god, I've hand-sewed half of that, and I'm sure it doesn't look good." It was nerve-racking, but it was also something I'll never forget. She made us wait, and then said she was sending the buyers up. And once Dawn said, "I want you to go shop this collection," they did.

—Lela Rose, designer

Opposite:
"Open All Night,"
store window,
2005.

"THE 80S WERE SHORTER THAN MOST DECADES BECAUSE IT WAS OPEN ALL NIGHT."

GLENN O'BRIEN

Even when you don't have amazing deliveries because of a different project, or a problem, or whatever, it's not like the Bergdorf team is just anyone in the business. They're my friends. They're kind of my family in a way. They give you the support, the comfort, the love, the respect. And I'm giving it back to them.

—**Alber Elbaz, designer**

I n 1981, we did a show for Fendi furs at the
Pulitzer Fountain, where we turned the fountain
into a runway. There was a drought in New York
that year, and the Pulitzer Fountain was not work-
ing. The city was not in such great shape back then,
and they didn't want to have the water running
because of the drought.

It was an evening show, and we had amazing
lights designed for the runway. We lined the tiers
of the fountain with black Mylar, so that when we
filled it with water and lit it, it would be this beauti-
ful runway, with the girls in the furs.

On the day before the show, a five-thousand-gallon
stainless-steel truck pulled up and spent most of the
day filling the fountain. We had made arrangements
with the parks department to have them insert all
the proper plugs. Filled, it looked beautiful.

The Fendi sisters were here, and we were doing
fittings late into the evening. And just as we were fin-
ishing up, Carla Fendi decided we needed to turn on
the lights so that she could see how the coats would
look against the fountain. The furs were locked up at
this point, so we had to call the head of operations to
unlock the vault. So at 11:30 at night, a few of us were

out there, wearing the coats on the runway so that Carla Fendi will be satisfied with the lighting.

Everything looked great and we all went home after midnight.

The next morning, I was walking down Fifth Avenue toward the fountain. Even from a distance, it looked like there was no water in it. I was so exhausted, I thought I was hallucinating. But as I got closer, I realized it was empty.

I got on the phone with the parks department to figure out what was going on. They forgot to put in the plugs. "Not to worry," they said. "We will fill the fountain for you. Just don't tell anyone where the water came from."

The fountain was filled again, but then, of course, the drought ended. It started raining. I was calling weather stations around New York, demanding to know the forecast. Luckily, the skies cleared just before the show started. The show was incredible, and we all made it up to the Goodmans' apartment for a private dinner with the Fendis just before it started pouring again.

—Mallory Andrews, senior vice president, sales promotion, marketing, and publicity

We used to do these wild fashion shows for some of the designers, using all the land-marks of New York City—the Prometheus Fountain at Rockefeller Center for Giorgio Armani, Studio 54, the Armory for Claude Montana. We even rented the Big Apple Circus tent for Jean Paul Gaultier and flew him in by helicopter.

— Susie Butterfield, former senior vice president

SABER SLIM TAILOR'S TRIUMPH...natural ranch mink down the middle, round the wrists. By Jack Sarnoff. Blackest worsted. $600. Coats, Third Floor.

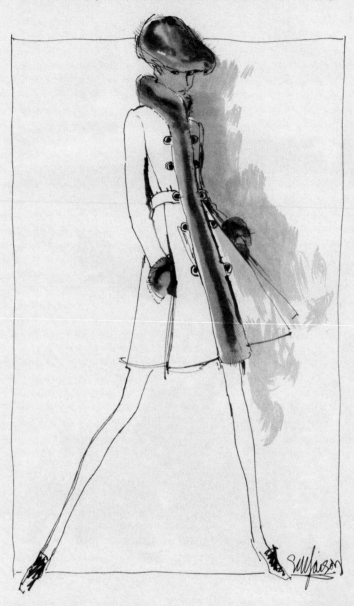

BERGDORF GOODMAN

ALLURING *since 1901*

Introducing
AZZEDINE ALAÏA
Third Floor 212 753 7300

We did a show for Azzedine Alaïa in November 1982. He came over from Paris with his entourage, including his friend Thierry Mugler and Azzedine's dog, Pattes à Pouf, or "paws of puff." Mr. Neimark and Dawn Mello gave the little dog a Paddington Bear, which he proceeded to carry all around the store, chewing it up like crazy. I recall there were also a few accidents here and there.

Azzedine Alaïa does not speak a word of English. I was the only one working on the show who spoke French. So I served as the head of public relations, head of events, and also translator for the week. Azzedine kept saying to make the runway six inches tall. But Thierry Mugler kept telling Azzedine that the runway needed to be fourteen inches. So they went, going back and forth in French.

The show at the store turned out beautifully. We had carriages outside waiting to take everyone to a dinner at the Dairy in Central Park. We had groomed the horses and put bouquets around their necks. At the party, there was a separate little table, with a black-and-white-striped cloth, for Pattes à Pouf.

— **Mallory Andrews, senior vice president, sales promotion, marketing, and publicity**

Fashion's Night Out at Bergdorf is a mob scene. You can't move. But then you don't want to be anywhere else. That's the kind of excitement it generates.

My dog, Stevie Nicks—a mutt, a Yorkie and Chihuahua mix—participated in a dog fashion show at Bergdorf for Fashion's Night Out a couple of years ago. She didn't really handle it so well. She's six pounds, so she's very small. I think the crowd freaked her out, and the bigger dogs freaked her out more. But she held her own onstage.

I had to dress her in something, so I made her a black monkey fur coat to go over her body. It made her look tough, even though she wasn't feeling that way.
—**Thakoon Panichgul, designer**

Page 190: Bergdorf Goodman's advertisement for a mink-trimmed Jack Sarnoff coat, *Vogue*, October 1969. Page 191: Bergdorf Goodman's advertisement for Azzedine Alaïa, the *New York Times*, fall 2009.

For the first Fashion's Night Out, no one really knew how many people would come or what would happen. It was our idea to bartend in the BG Restaurant. We love the café. Bergdorf designed the drink for the night, but we mixed the drinks ourselves. There was a ton of people. I don't think they expected so many to show up. We heard the crowd pulled the doors off the hinges, but we couldn't see any of that. We were too busy behind the bar. By the end of the night, we'd run out of liquor.
—**Ashley Olsen, designer,**
The Row and Elizabeth & James

I made a whole dollar in tips. I remember that. And also walking away with sticky hands and sticky feet.
—**Mary-Kate Olsen, designer,**
The Row and Elizabeth & James

Opposite:
An advertisement
for Bergdorf
Goodman,
Vogue, 1936.

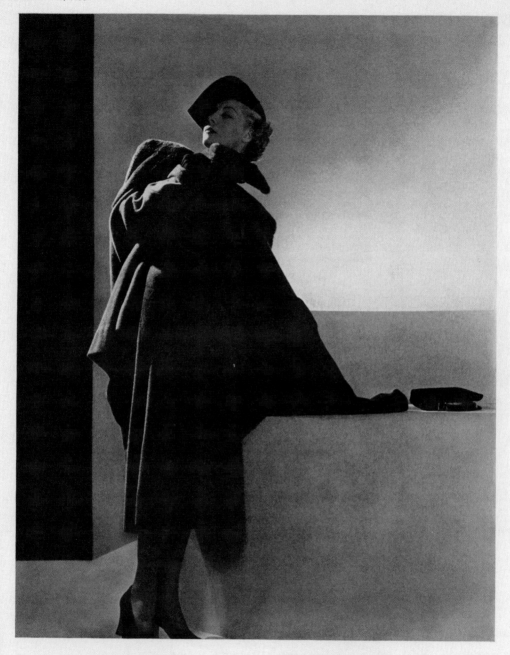

The new perversity—bulk over slimness—here presented at its smartest. The full wool cape
bears shoulder crests of nutria. The close-fitted dress is buttoned and
buckled with tortoise. Both are marron. The cape reverse
is nutria brown. Ready-to-wear original.

Anytime I've ever come to a party here, I feel like I've stepped onto the set of *Breakfast at Tiffany's* and the apartment party scene. There are artists, poets, writers, models, gossip columnists, designers, editors in chief, wannabes, society ladies, all under one roof. There's an energy that's palpable. You can feel it.

Fashion's Night Out is the antithesis of Bergdorf. It's a circus, but it's done in a way that feels Willy Wonka or Alice in Wonderland. The first year that I participated, I was a game piece on a life-size game board called Fashion Rules. The participants were myself, André Leon Talley, Linda Fargo, and Donna Karan. Standing there, I thought, "Oh my god. This is nuts." But it was in some way a strange metaphor for our lives.

—**Robert Verdi, stylist**

The year I went [to Fashion's Night Out], I was escorted through by six security guards and signed several fashion students' body parts and iPhones. It was a very . . . interesting evening. It's like the Beatles have come to town. It's a total oxymoron, seeing these crazed fashion students swarming inside Bergdorf, climbing on counters and up steps in fine jewelry and Chanel bags to get a glimpse of someone. You're like, "Oh my god. All hell is breaking loose."

—**Rachel Zoe, stylist and designer**

I think it's really interesting for a store to have a magazine, like Bergdorf Goodman does. Having a magazine of your own enables you to take your identity and personality one step further. You're not a guest in somebody else's home. You can create the atmosphere you like. It's a great vehicle for showing fashion, but it also shows we have a sense of humor.

— **Glenn O'Brien, editor in chief,** *BG Magazine*

One of the first memories I have of New York was walking by Bergdorf Goodman, looking at the windows and just wanting to be a part of it all. When I got my first Fifth Avenue window, I was such a nerd and snuck up here late at night and took a bunch of pictures out front so I could send them to my parents. But I was so proud because to me, a Bergdorf window is a beacon of success. It's such a triumph, seeing my work displayed.

The window had JASON WU painted really large on the glass and there were three pieces from my spring 2009 collection. It was all black and white with a teal background. I still look back and can remember it vividly.

—**Jason Wu, designer**

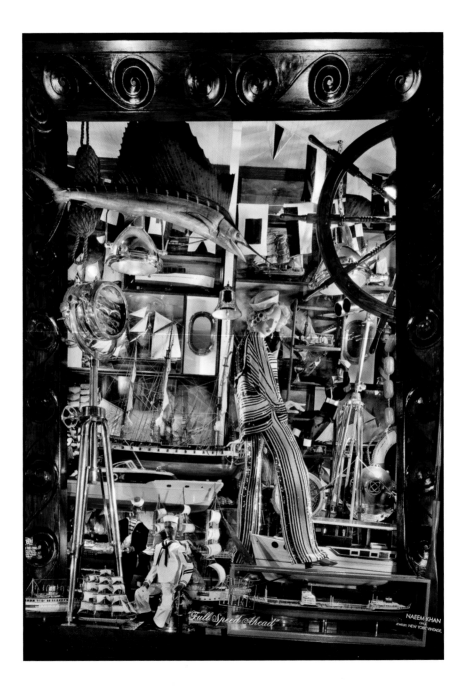

"Full Speed Ahead"

NAEEM KHAN
ONLY
JEWELRY NEW YORK VINTAGE

Our first window said RODARTE. There were two or three things in it, including this black wool and gray georgette pleated gown. And then a pale yellow pleated dress with, like, white and black feathers in it. We came and posed in front of it. It was like a real photo shoot outside that window.

—**Kate Mulleavy, designer, Rodarte**

The first and only time I ever modeled in a store window was at Bergdorf Goodman. It was a sunny day, so it was boiling after five seconds in the window. I was very animated at first—moving around. After ten minutes, there was a massive amount of people watching. It was like being onstage—a very funny experience. It was just very, very hot. After fifteen minutes, I had to get out.

—**Christian Louboutin, designer**

Opposite:
"Full Steam
Ahead," holiday
store window,
2010.

W e were doing a Richard Tyler collection window and there was something ethereal about the clothes. The dresses were diaphanous and white. So we said, "Wouldn't it be great if we could re-create heaven?"

We were going to float the mannequins—something we had never attempted before. And all we could think was, "How do we hide the strings?" We're always sticklers for that, disguising our tricks. So we said, "Aha! Smoke machines."

At that time, it wasn't exactly easy to get a smoke machine. One of us came up with the idea of going down to Canal Street, where all the clubs go to get music systems and lights and all those special effects from club suppliers—a very reputable group of guys, by the way. Cash only. Sign on the dotted line with the firstborn child before you get out the door.

We select this smoke machine, and we say, "Listen, we need to do a trial with this. We've got to see if it even works."

They said, "No, no. Not allowed." And believe it or not, we committed anyway. That's how badly we wanted this window to work. So we pay them in cash. We bring the machine up to Bergdorf. We go into the window and we hit the "on" switch.

I don't know how we didn't realize this at the time, but the windows actually locked from basically the wrong side. They should lock so that somebody on the sales floor isn't able to get into a window—not so that someone inside of the window can't get out!

We turned on the smoke machine and the thing was gangbusters. It wasn't like a little *wheee*—it was *WOOOOSH*! And soon it was actually choking us. We were basically beginning to asphyxiate. And we're like, "Where's the 'off' button? WHERE'S THE 'OFF' BUTTON?!" But we couldn't shut it off. And we couldn't see anything.

So here we are: we can't see, we can't shut it off, we can't get out of the window because the door has locked behind us. We started pounding on the door. This was in the fine jewelry department. So one of us is pounding on the door, the other one is starting to scrawl HELP! in the condensation of the windows, in case someone outside sees us. At first we were kind of laughing about it and then we realized, "Oh my god, we're going to die in here."

Finally, a seller in the jewelry department opened the door and we tumbled out in a huge cloud of smoke.

—Linda Fargo, senior vice president of the fashion office and store presentation

That heaven window was like a sixties halluci-nogenic trip. Not only was it trippy and lovely and soft to look at, but the whole experience was very mind-altering. The smoke was some sort of chemical. It started to get on the glass and left a sticky film. And then it started to get on all these gossamer fabrics. And the dresses started to look drippy and wet. Not very heavenly at all.

On top of that, customers were ready to call 911 because they kept seeing smoke trailing out of the windows and into the store. It was the only time that we ever changed a window, because it abso-lutely did not work.

—James Aguiar, associate creative director, windows and visual merchandising

I'm not afraid of the term "window dresser." Most window people will not say that. They'll call themselves visual merchandisers or something grandiose like that. But I mean, why not use the more modest term and then go way overboard with the windows?

It's advertising: a little fashion, a little theater, a little installation art, a little storytelling, but commercialized. I tell people what I do is something between an architect and a cake decorator. It's a perfect job for a dabbler. But you have to have a high-camp sensibility. If you don't have that, you may as well be an interior designer.

Every window has some element of humor in it. There's wit. It's not whimsy. It's wit. Sometimes the mannequin is just put in there in the last minute. Even she doesn't know quite why she's there.

I've done four thousand windows here at Bergdorf since 1996. Particularly with our holiday windows, we don't confine ourselves just to things that are on sale in the store. We go straight to the designer showrooms and try to find the more outrageous one-of-a-kind garments. It doesn't mean it's not for sale here at Bergdorf—everything is—but maybe it's a special order instead of off the rack.

—David Hoey, senior director, visual presentation

I work with David [Hoey] and the visual department at Bergdorf Goodman to create windows and props and install them. For one window we did, David wanted to do a mosaic. They had done a tile window once before, a jungle, but I wanted to introduce more natural, organic elements, because I wanted it to feel luxurious and really beautiful and really approachable—for me, cold tile can be really uninviting. So I started thinking about gradation and the way that fish scales look.

David said they should be background fish. He didn't want them to show off too much. We had to use what we had and keep it simple, and to not let any of the fiberglass show so that we didn't break the illusion or end up with something that looked like it was out of a dentist's office.

So we were building this solid mosaic background with the fish—very intricate work. And David had to go out and buy a new first-aid kit for us. We were all cutting our fingers constantly. But that's part of the territory.

I once did a whole series of Tony Duquette windows that I loved. Those were an extraordinary tribute to him.

There is not an unlimited budget. I think that's a big misunderstanding about the Bergdorf windows. We don't have crazy salaries or a big budget to work with or anything like that. It's a real labor of love. But I think that with any art or creative field, the limits on your project are what push you to make something great.

—**Brett Day Windham, artist**

I was passing by Bergdorf Goodman, and I almost fainted when I saw that the windows were filled with my shoes. The windows were filled with things from where I had worked too—pieces of my studio and everything. It was very beautiful.

—**Manolo Blahnik, designer**

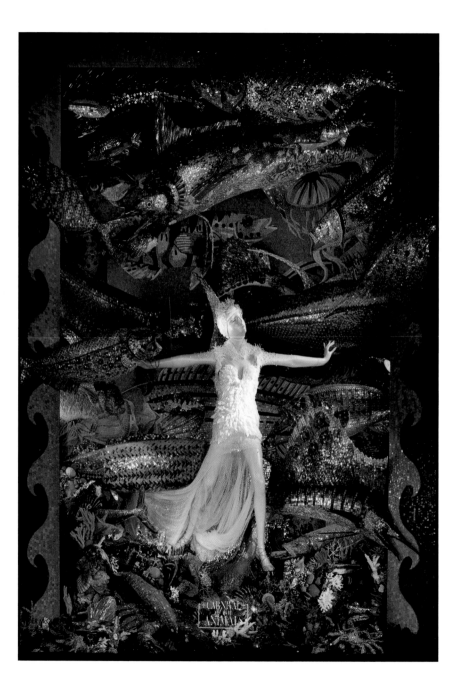

CARNIVAL of the ANIMALS

My mom used to go to Bergdorf a lot when I was a kid, and I would just peer into those incredible windows. Then on top of it, you know what they sell is an intense kind of luxury. There's no other feeling like that.

—Jack McCollough, designer, Proenza Schouler

I got the surprise of my life, seeing a dress from my very first collection in the window at Bergdorf Goodman. It was one of the most magical yet unexpected moments in my career. I was in New York, driving down Fifth Avenue, and I looked over and there it was. I just couldn't believe that this white corset dress I had designed was in the window right next to YSL.

—Victoria Beckham, designer

Opposite: "Testing the Waters," holiday store window, 2011.

When Bergdorf first bought my shoe collection, they gave my husband [photographer Craig McDean] a window to design for them, which was pretty intimidating because the windows are so incredible. He'd never done a window before. He did it with an artist friend. It was a never-ending window—just window upon window upon window upon window upon—it looked like it just went on for ages. The night it went up, I was having dinner downtown with friends, and I made everybody get in a taxi to come up and see it.

—Tabitha Simmons, shoe designer

I think of being in the windows as a really important event. Linda Fargo and I always collaborate on making that one special piece, even though it might not be in my collection. We go to great lengths to get the story, to coordinate it with the dress I'm going to make for them.

One year, we were working on a fantasy idea. There was a flying elephant and on the elephant was this girl entirely encrusted in Swarovski crystals.

That dress was so heavy, but so glamorous—it looked like a crystal woman flying in on an elephant.

Practically speaking, we were shredding pieces of chiffon and hand-sewing crystals.

First, you have to dream of something. Then I sketch the idea, and my patternmakers drape the dress for me. Embroidery is a very important element of my collection, because of my family's background. So I'll make a swatch. Then I'll send the idea to my factory in India, and they will embroider it according to what I'm thinking.

In embroidery, you have threads. You have beads. And you have colors. And then there is the combination of all those things. So you really have to be doing this for many, many, many years in order to have all this in your head and know how something will turn out. I've been aware of embroidery since I was a little boy, going to my father's factories in India. So, for me, it comes very easily.

—**Naeem Khan, designer**

I used to work next door to Bergdorf Goodman at Geoffrey Beene for years. And I used to always come and work on the windows here with Linda Fargo. I used to come here at three in the morning, when they used to do the windows. I loved that sensation of being here at Bergdorf in the middle of the night, when it's just you and the mannequin. There's a kind of secret and mystery and darkness about it.

—**Alber Elbaz, designer**

When I was a kid at school at Parsons, there were two things they used to do which they don't do anymore. One, we used to have a class at the Met, in the costume archive. The other thing we used to do was go weekly to Bergdorf to sketch the windows. And it was mortifying. Because you thought, "What am I, some kind of crazy, to stand in front of the windows like this?" But it was a great lesson because we learned to sketch really fast.

—Isaac Mizrahi, designer

We've done a room that is upside down and put in faux ceilings and had everybody standing literally upside down, without letting the clothes fall. It looks like magic. We have done snowfall and had the windows look totally like a snow globe. We're pretty low-tech. That time, we were scooping the confetti up every day and loading it back into the machine. We don't have a budget for high tech, so we find ways of doing things that are a little old-fashioned.

One of my favorite windows happened when Dawn Mello, president of Bergdorf Goodman at the time, was on the board of the American Ballet Theatre. She asked us if we would help open the season with windows.

We wanted to immerse ourselves in the spirit and the culture of it, so we watched a few rehearsals, and then we went to see the old costumes and the old fragments of sets at a warehouse in Queens. So we take a car—past the graveyard, past the railroad yard. There, in this obscure warehouse, the gate goes up and we see a football field of crates—red crates stamped ABT, with the names of the productions on them, like *Swan Lake*.

It was very Rumpelstiltskin, very needle in the haystack. We thought, "How are we ever going to figure this out? What are we going to use?" It also felt very *Citizen Kane*.

So we started digging through these crates, but what we didn't realize is that these costumes are used year after year after year. Only the principal dancers have new costumes made for them for a new production. So they are worn, worn, worn. And people have been, you know, dancing . . . sweating . . . in these costumes. And believe me, you could tell.

The tutus really only stand out when they're on the body. When they're in a box, they're flat as a pancake. They stack them like donuts. We got so fascinated with the way these pieces were stored that we said, "Let's use this, all of it—let's use the crates."

Instead of focusing on the stage, we went behind it and literally turned the prosceniums around so the viewer kind of got the backstage view. And they could see this treasure trove of history and culture literally bursting at the seams with sequins and jewels and crowns and just years and years of patina.

—**Linda Fargo, senior vice president**
 of the fashion office and store presentation

SCATTER MY
ASHES AT
BERGDORF GOODMAN

"It's pretty extreme that people would think about scattering their ashes in Bergdorf, but I'm sure it happens. If someone I knew put that in their will, I think it would actually make me laugh, because it would show me that their sense of humor was continuing on."

—Tory Burch, designer

I n the April 30, 1990, issue of *The New Yorker* magazine, Victoria Roberts published a cartoon showing two women sitting across from each other at a lunch table. The caption read: "I want my ashes scattered over Bergdorf's."

Turns out, quite a few Bergdorf Goodman customers have actually considered dispersing their remains *Shawshank Redemption*–style around the store, and many more think of Bergdorf Goodman as a fitting final resting place.

"I wanted to live in a department store when I was about twelve," cartoonist Roberts says of her ongoing fascination with the store. "I grew up in Mexico, and my mother used to travel, and one of the things I always remembered about New York was Bergdorf Goodman. Then I came here when I was nineteen and bought something and did a collage from the Bergdorf Goodman receipt. When I think of Bergdorf, I think of little things in exquisite detail.

"I really don't remember specifically how I came up with the caption for that cartoon," she says. "But it was one of my first published in *The New Yorker*. I didn't plan it. I think this one might have arrived, perfect, into the world."

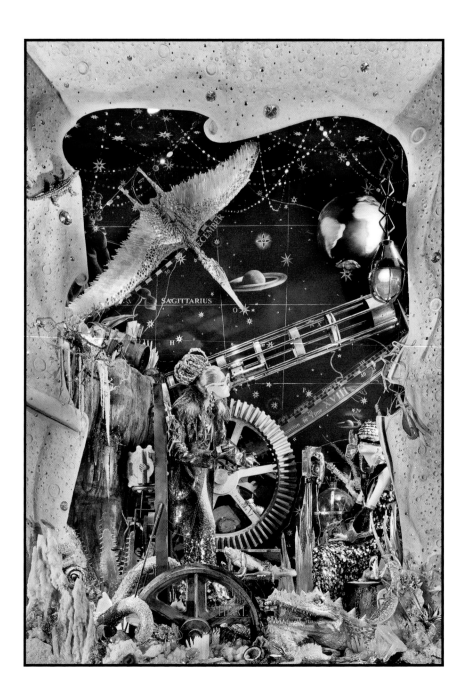

Even those who haven't sprinkled relatives throughout the store go there to remember departed loved ones. "Whenever my family came to New York from Kansas City, my mother, older sister, and I would slip off to Bergdorf," Anne Kreamer, author and journalist, says. "Later, I'd come down from college to meet Mom for a weekend of shopping in the city. Although my mother is long deceased, now that I live in New York, the store is where I still sense her most. She's by my side when I'm checking out new shoes and when I'm having my favorite salad, the Gotham."

If there are ghosts at Bergdorf Goodman, they're the happy kind, left to drift through this enchanting place as if in a peaceful dream, where there's no wait for a dressing room and anything you want is yours.

Opposite:
"Daytripping,"
holiday store
window, 2010.

Well, of course we all know the cartoon "Scatter my ashes in Bergdorf Goodman." But in my act, I always say my husband committed suicide, and he wanted me to visit him every day. So I had him cremated and scattered in Bergdorf. And I haven't missed a day. That's in my act, to this day.

My own will, I like to say, starts with "Scatter me in Bergdorf Goodman, in the jewelry department, handbags, fine women's dresses, and Betty Halbreich's office." So Betty, one day, is going to be given a sack, and somebody's going to have to spread it around.

I also had a friend named Thomas Corcoran who loved the store and loved fashion and shopping. And when he died and was cremated, I took his ashes and dropped them into every single store that he loved. And you guys may not know it, but there's some of him here at Bergdorf too. I just sprinkled him all around.

—**Joan Rivers, comedian**

My mother used to get mad at me when I worked on Yom Kippur. This was before cell phones, but she would always call me and yell at me for working on a High Holiday. So I would ask her, "Mom, where are you right now?"

And she'd say, "Bergdorf." So her idea of celebrating Yom Kippur was to go shopping at Bergdorf Goodman. We always knew where to find her. I tried not to look for her in general, but if you really needed her, you knew where to go.

There are great pictures of her from the seventies in a Pucci dress, pregnant, smoking cigarettes, with a drink in her hand. She was always unbelievably well dressed. When she died, we actually had to go to Hong Kong to close up her apartment, and when we opened her closet, there were twelve identical—very short, because my mother was, like, four one—mink coats, all from Bergdorf Goodman. Even though Hong Kong is, like, nine million degrees year-round.

She died suddenly, without a final will, so my brother and sister and I were sitting around, talking about where we would most want to scatter her ashes. And Bergdorf came up, in all seriousness. We all agreed that was where she would want to be.

My friend the director Barry Sonnenfeld actually came up with an idea of how we could do it—like that scene in *Stalag 17*. You make a hole in your pocket and put the ashes in and then you walk around the store, so the ashes get sprinkled out of your pants.

We realized this was just too much. The ashes didn't end up in Bergdorf, even though it is what my mother would have wanted.

—Neil Kraft, owner, KraftWorks

My mom passed away . . . and my sister and brother and I were arguing and having a really hard time figuring out the plans for her funeral. And I remember sitting in her living room and talking to my sister and brother about how we were going bury her ashes. And I said, "You know, I just don't think that it's right to buy one of those ugly things from the funeral home. I really think we should bury her in a Bergdorf box because she loved Bergdorf and this was like her home away from home."

We didn't end up doing that. I guess my sister and brother thought it was too frivolous. But I thought it was the perfect solution in a difficult situation.

—**Kate Betts, contributing editor,** *Time*

BERGDORF GOODMAN

SPLENDID *since 1901*

OSCAR DE LA RENTA

View the Spring 2011 Collection
Monday, March 7–Tuesday, March 8
Fourth Floor 212 872 2656

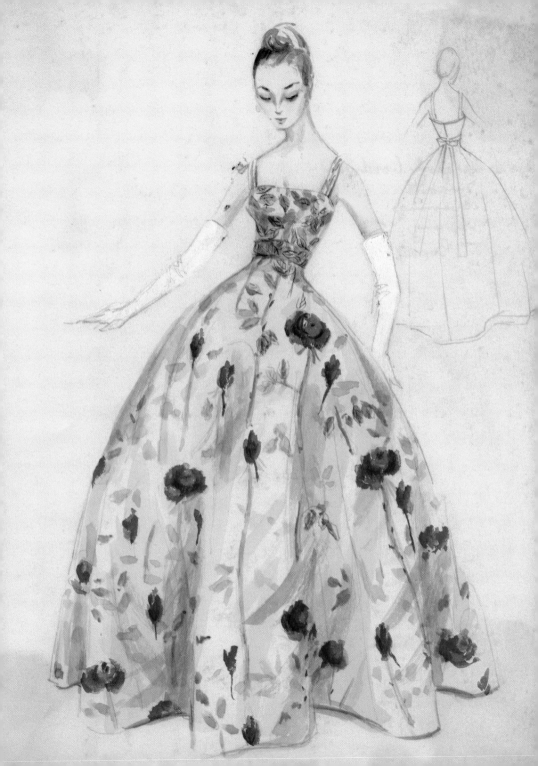

I remember a woman whose husband was complaining about how much money she spent on Manolo Blahnik shoes at Bergdorf Goodman. And she said, "Okay, honey, you know what? If it bothers you so much, when I die, spread my ashes at Bergdorf Goodman in the shoe salon. Because basically that's where I spend all my time. It's where I'm the happiest. It's not the lake house where we raised the kids. It's not the house in Greenwich where we give parties every Christmas. When I'm celebrating, when I'm depressed, when I'm sad, I go to Bergdorf Goodman and the shoe salon."

The husband just had this look on his face, like, "You know, you're even crazier than I anticipated." But she was being serious. He was complaining about their American Express bill, and she was being honest.

Practically speaking, I'm not even sure that it's legal. And what happens next? The cleaning guys come in and vacuum her up?

— **George Malkemus, chief executive officer, Manolo Blahnik**

I remember being on the seventh floor of Bergdorf Goodman. I had purchased something and I was listening to three Frenchwomen speaking. They were here on vacation. The seventh floor of Bergdorf had become a destination for them. One woman, who was excited as her purchase was being rung up, said, "Well, when I die, I want you to take my ashes and sprinkle them on the seventh floor of Bergdorf Goodman." I thought, "Hmm, she may not be far off on that. That's a pretty good idea."

— **Susan Lucci, actress**

Page 226: Bergdorf Goodman's advertisement for Oscar de la Renta, the *New York Times*, spring 2011.
Page 227: Balmain gown, spring 1957, original sketch rendered by Bergdorf Goodman.

I f someone ever asked me to scatter their ashes here, I would go up on the roof and cast them to the wind and down over the facade of the building. Which would eventually get Windexed, one hopes.

— **Mickey Boardman, editorial director, *Paper***

L et's be honest, I think whenever anyone says, "Well, where would you like to have your ashes scattered?" you want to have your ashes scattered at a place that is just blissful. And I know a lot of New York women—it could be the most glorious sunny day and Central Park in bloom and divine—who would rather be inside here at Bergdorf.

Some people want a gorgeous beach to have their ashes scattered. Some people, a country meadow. Some people, off of a ship. But I know a lot of women for whom, quite frankly, this is their fulcrum. This is their dream place. This is where they want to be forever.

— **Michael Kors, designer**

Opposite:
"One Forty-Nine
PM," store
window, 2009.

230

ACKNOWLEDGMENTS

For anyone interested in the history of Bergdorf Goodman and its site, I highly recommend Booton Herndon's wonderful *Bergdorf's on the Plaza: The Story of Bergdof Goodman and a Half-Century of American Fashion* and John Foreman's *The Vanderbilts and the Gilded Age: Architectural Aspirations, 1879–1901*, both of which I leaned on heavily while assembling this book. Ira Neimark's *Crossing Fifth Avenue to Bergdorf Goodman: An Insider's Account on the Rise of Luxury Retailing* is another rich resource.

The *Scatter My Ashes* project would not have been possible without Mallory Andrews at Bergdorf Goodman. Long before our first interview was taped, Mallory was gathering anecdotes about the store, establishing a living history for Bergdorf Goodman when it had no formal archive.

Matthew Miele, director of the accompanying documentary, had the unenviable task of filming many of these sessions, often inside the store during business hours, filtering out noisy escalators, curious shoppers, buzzing overhead lights, and ambient Muzak. He also stepped in to ask the questions when I, seven months pregnant, retired to complete the book.

My editor at HarperCollins Publishers, Elizabeth Viscott Sullivan, provided invaluable guidance and immensely improved the structure of the manuscript.

Amanda Urban and Kate Lee at ICM first suggested me for this project and provided much-needed encouragement along the way.

Teril Turner and Barbara Ragghianti wrangled scores of designers, celebrities, socialites, and Bergdorf Goodman employees and kept the calendar full of fun surprises. Liz Keating was a tremendous help researching the history of the store and maintaining order on set. And Tracy Costa transcribed entire days' worth of interviews, sometimes overnight.

During the year I worked on *Scatter My Ashes*, my family moved from Brooklyn to Boston. We also welcomed a little girl (whom I hope to soon take shopping at Bergdorf Goodman). My husband, Seth, and son deserve medals for surviving the chaos with me. Their love and support astound me daily. For my family, IAMBAMBIM.

PHOTOGRAPHY AND ILLUSTRATION CREDITS

FOREWORD: Page 8: Cartoon: Victoria Roberts, "I want my ashes scattered over Bergdorf's." *The New Yorker*, April 30, 1990. © Victoria Roberts/*The New Yorker* Collection.

INTRODUCTION: Page 21: Cornelius Vanderbilt residence, Fifth Avenue and 58th Street, New York City. © Collection of the New-York Historical Society, New York. **Page 25:** Photograph: Richard Averill Smith, Bergdorf Goodman store front, 1935. © Mattie E. Hewitt and Richard A. Smith Collection. Courtesy of the *New York Times* and the New-York Historical Society, New York. **Pages 30–31:** Photographs: Howard Graff, "Living Above the Shop," *House Beautiful*, August 1965, pages 100–101. Reprinted with permission of *House Beautiful* © 1965. **Page 32:** Photograph: Nena and Andrew Goodman. Associated Press, 1939. © Associated Press. **Page 38:** Photograph: Jerome Zerbe, "Royal Family of Fashion," *Look*, December 4, 1951. Courtesy of the Library of Congress, Washington, DC.

CHAPTER 1: Page 48: Photograph: Ormond Gigli, "Posh Palace of Fashion," the *Saturday Evening Post*, April 14, 1962. Photograph courtesy of Ormond Gigli. **Page 54:** Drawing: Balmain (8372), Bergdorf Goodman French Collection, fall 1951. Courtesy of the Fashion Institute of Technology/SUNY, FIT Library Department of Special Collections, and FIT Archives. **Page 55:** Advertisement: Bergdorf Goodman/Tom Ford, the *New York Times*, fall 2011. Model: © 2012 Liu Wen at Marilyn. Photograph: Miguel Reveriego, © 2012 Miguel Reveriego. **Page 63:** Photograph: Ricky Zehavi and John Cordes © 2012. "One Thousand Vintage Barbie Outfits," 2011.

Page 70: Drawing: Chanel (B282), Bergdorf Goodman Imports, spring 1965. Courtesy of the Fashion Institute of Technology/ SUNY, FIT Library Department of Special Collections, and FIT Archives. **Page 71:** Advertisement: Bergdorf Goodman/ Valentino, the *New York Times*, spring 2011. Model: © 2012 Patricia Van Der Vliet at Marilyn. Photograph: Jason Kibbler, © 2012 Jason Kibbler. **Page 80:** Advertisement: Bergdorf Goodman/ Michael Kors, the *New York Times*, fall 2011. Model: © 2012 Liu Wen at Marilyn. Photograph: Miguel Reveriego, © 2012 Miguel Reveriego.**Page 81:** Advertisement: "Instant Pepper Exclusive at $310," *Vogue*, September 1, 1960. Suit: Christian Dior. Photograph: Ynocencio. Courtesy of Condé Nast. **Page 88:** Advertisement: Bergdorf Goodman/Givenchy, the *New York Times*, fall 2010. Model: Jacquelyn Jablonski at Supreme. Photograph: Jason Kibbler, © 2012 Jason Kibbler. **Page 89:** Drawing: Balmain (B778), Bergdorf Goodman Imports, Evening, spring 1966. Courtesy of Fashion Institute of Technology/SUNY, FIT Library Department of Special Collections, and FIT Archives. **Page 94:** Advertisement: Bergdorf Goodman, *Vogue*, August 1, 1919. Courtesy of Condé Nast. **Page 100:** Photograph: Ricky Zehavi and John Cordes © 2012. "The Scenic Route," vaudevillian train fantasy with rotating backdrop, Oscar de la Renta dress, Bergdorf Goodman holiday windows, 2010.

CHAPTER 2: Page 107: Ricky Zehavi and John Cordes © 2012. "Subway Twister," one of a set of windows inspired by New York City's civic institutions, 2006. **Page 115:** Advertisement: Bergdorf Goodman, *Vogue*, October 15, 1936. Photograph: Horst, Paris. Courtesy of Condé Nast. © 2012 Estate of Horst P. Horst/Art + Commerce. **Page 120:** Photograph: Ricky Zehavi and John Cordes © 2012. "All Things Chanel," 2005. **Page 126:** Illustration: Larson, sketch of Jacqueline Bouvier Kennedy's gown for John F. Kennedy's

Inaugural Ball, designed by Ethel Frankau, fashion director, Bergdorf Goodman, 1960. **Page 127:** Photograph: Otto Bettmann. Lyndon B. Johnson and President and Mrs. John F. Kennedy, 1961. © Bettmann/CORBIS. **Page 131:** Photograph: Ricky Zehavi and John Cordes © 2012. "Comparative Philosophy: Karl Lagerfeld versus Coco Chanel," juxtaposition of current Chanel ensemble (designed by Lagerfeld) and vintage Chanel dress, 2005. **Page 136:** Advertisement: Bergdorf Goodman/ Akris, the *New York Times*, spring 2011. Model: © 2012 Patricia Van Der Vliet at Marilyn. Photograph: Jason Kibbler, © 2012 Jason Kibbler. **Page 137:** Drawing: Balmain (B934), Bergdorf Goodman Imports, Evening, spring 1963. Courtesy of the Fashion Institute of Technology/SUNY, FIT Library Department of Special Collections, and FIT Archives. **Page 144:** Drawing: Lanvin (B784), Bergdorf Goodman Imports, Evening, 1966. Courtesy of Fashion Institute of Technology/SUNY, FIT Library Department of Special Collections, and FIT Archives. **Page 145:** Advertisement: Bergdorf Goodman/Lanvin, the *New York Times*, spring 2011. Model: © 2012 Patricia Van Der Vliet at Marilyn. Photograph: Jason Kibbler, © 2012 Jason Kibbler. **Page 151:** Photograph: Ricky Zehavi and John Cordes © 2012. "Gothic Splendor," 2006, in collaboration with Douglas Little and *House and Garden*.

CHAPTER 3: Page 160: Photograph: Ormond Gigli, "Halston Fitting a Hat," the *Saturday Evening Post*, 1962. Courtesy of Ormond Gigli. **Page 166:** Advertisement: Bergdorf Goodman/Oscar de la Renta, the *New York Times*, spring 2010. Model: Jacquelyn Jablonski at Supreme. Photograph: Jason Kibbler, © 2012 Jason Kibbler. **Page 167:** Drawing: Lanvin (832), Bergdorf Goodman Imports, spring 1967. Courtesy of the Fashion Institute of Technology/ SUNY, FIT Library Department of Special Collections, and FIT Archives. **Page 172:** Photograph: Ricky Zehavi and John Cordes © 2012. "The Psychiatrist" from the Phobia series,

Bergdorf Goodman, 2011. Paintings: Mark Gagnon. **Page 178:** Advertisement: Bergdorf Goodman, *Vogue*, March 15, 1945. Courtesy of Condé Nast. **Page 185:** Photograph: Ricky Zehavi and John Cordes © 2012. "Open All Night," 2005, created for the publication of the book *So8os* by Patrick McMullan. **Page 190:** Advertisement: "Saber Slim Tailor's Triumph." *Vogue*, October 1, 1969. Coat by Jack Sarnoff. Illustration: Larson, courtesy of Condé Nast. **Page 191:** Advertisement: Bergdorf Goodman/Azzedine Alaïa, the *New York Times*, 2009. Model: Giedre Dukauskaite at Women. Photograph: Jason Kibbler, © 2012 Jason Kibbler. **Page 195:** Advertisement: Bergdorf Goodman, *Vogue*, September 15, 1936. Courtesy of Condé Nast. **Page 200:** Ricky Zehavi and John Cordes © 2012. "Full Steam Ahead," a gravity-defying collection of nautical antiques, Naeem Kahn ensemble, Bergdorf Goodman holiday windows, 2010. **Page 208:** Photograph: Ricky Zehavi and John Cordes © 2012. "Testing the Waters," environment in Italian mosaic tile, dress by Alexander McQueen, from the Bergdorf Goodman holiday windows, 2011. Artist: Brett Windham.

CHAPTER 4: Page 220: Photograph: Ricky Zehavi and John Cordes © 2012. "Daytripping," moonscape from the "Wish You Were Here" set from the Bergdorf Goodman holiday windows, 2010. **Page 226:** Advertisement: Bergdorf Goodman/Oscar de la Renta, the *New York Times*, spring 2011. Model: © 2012 Patricia Van Der Vliet at Marilyn. Photograph: Jason Kibbler, © 2012 Jason Kibbler. **Page 227:** Drawing: Balmain (B870), Bergdorf Goodman Imports, Evening, spring 1957. Courtesy of Fashion Institute of Technology/SUNY, FIT Library Department of Special Collections, and FIT Archives. **Page 231:** Photograph: Ricky Zehavi and John Cordes © 2012. "One Forty-Nine PM," sculptural clock, 2009.

Page 240: Illustration: Megan Hess, *Brunch at Bergdorf's*, 2011. © 2012 Megan Hess.

SCATTER MY ASHES AT
BERGDORF GOODMAN

HarperCollins books may be purchased for educational, business, or sales promotional use. For information please write: Special Markets Department, HarperCollins*Publishers,* 10 East 53rd Street, New York, NY 10022.

First published in 2012 by
Harper Design
An Imprint of HarperCollins*Publishers*
10 East 53rd Street
New York, NY 10022
Tel: (212) 207-7000
Fax: (212) 207-7654
harperdesign@harpercollins.com

Distributed throughout the world by
HarperCollins*Publishers*
10 East 53rd Street
New York, NY 10022
Fax: (212) 207-7654

ISBN 978-0-06-219108-3

Library of Congress Control Number: 2011941338

Book design by Christine Heslin

Printed in United States of America
Second Printing, 2013

AUTHOR'S NOTE

While preparing this book, we heard many stories
about Bergdorf Goodman—from the touching to
the funny to the glamorous. We know there are
many more, and we'd love you to share yours.

Please contribute to BG Stories at
http://blog.bergdorfgoodman.com/bg-stories.

Or write us the old-fashioned way:
Bergdorf Goodman
Attention: Scatter My Ashes
754 Fifth Avenue
New York, NY 10019